IMAGES
*of America*

# THE DELAWARE AND RARITAN CANAL AT WORK

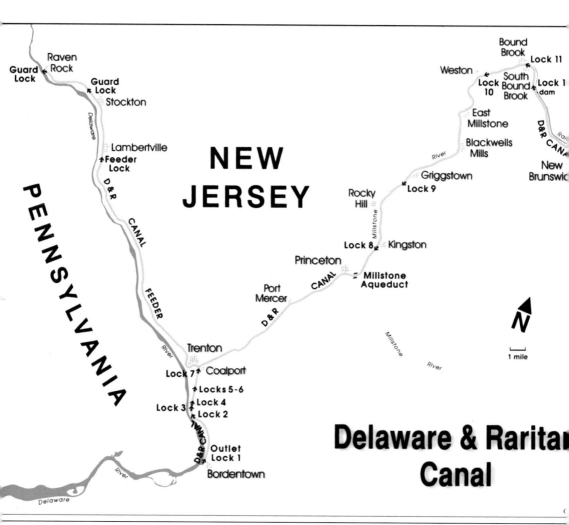

The route of the Delaware and Raritan Canal can be described as a Y shape. On the left (west), the feeder canal parallels the Delaware River, delivering water from the river to the summit of the main canal in Trenton. The main canal begins at Lock No. 1, opposite Bordentown off Crosswicks Creek, and continues in a northeasterly direction through Trenton, Lawrence Township, Princeton Township, Kingston, Rocky Hill, Franklin Township, South Bound Brook, and New Brunswick. (Courtesy of Gary Kleinedler.)

IMAGES
*of America*

# THE DELAWARE AND RARITAN CANAL AT WORK

Linda J. Barth

ARCADIA
PUBLISHING

Published by Arcadia Publishing
Charleston, South Carolina

Printed in the United States of America

Library of Congress Catalog Card Number: 2004102941

For all general information contact Arcadia Publishing at:
Telephone 843-853-2070
Fax 843-853-0044
E-mail sales@arcadiapublishing.com
For customer service and orders:
Toll-Free 1-888-313-2665

Visit us on the Internet at www.arcadiapublishing.com

# CONTENTS

# ACKNOWLEDGMENTS

This book would not have been possible without access to the photographic archives of the Franklin Township Public Library, the Historical Society of Princeton, and the Canal Society of New Jersey. William Brahms, head of Adult Services and Historical Collections at the Franklin Township Public Library, was extraordinarily helpful, sharing his time, suggestions, and assistance. Marisa Morigi, collections curator at the Historical Society of Princeton, most generously located, scanned, and copied photographs for me; Gail Stern, director, also provided valuable advice.

I am also grateful for the assistance of the following friends from historical societies, libraries, and other organizations around the state: James C. Amon, executive director of the Delaware and Raritan Canal Commission; Richard Hunter of Hunter Research in Trenton; Wendy Naldi, Trentoniana curator, Trenton Public Library; Margaret Hoffman and Doug Winterich of the Burlington County Historical Society; Barbara Ross, president of the Delaware and Raritan Canal Watch; Joanna Stem and Joseph Shepherd of the New Jersey Water Supply Authority; Clifford Zink, coauthor of *Spanning the Industrial Age: The John A. Roebling's Sons Company, Trenton, New Jersey, 1848–1974*; Christian Wolfe of the *Black River Journal*; Robert Miller of the New Brunswick Free Public Library; Elizabeth King of Johnson & Johnson; Bob Schopp, hydrologist, U.S. Geological Survey; James Pearsall and Heidi Walker of Zarephath; Richard Veit, archaeologist at the Staats House; Wilbur Bryan of the Old Millstone Forge Association; George Bebbington of the Somerset County Historical Society; Clara Higgins; Dennis Quinlan; Margaret Milesnick; Robert von Zumbusch; Bob Canfield; Tom McGough; members of my writers' group who graciously took the time to proofread sections of the book—Kristin Camiolo, Liza Jaipul, Barbara Khait, Doreen Lorenzetti, Maurice Meyers, Kimberly Ono, Mary Lois Sanders, Sharon Solomon, and Susan Watts; and finally, Bill McKelvey, Susan Poremba, and Barbara Westergaard, whose superior editing skills fine-tuned the text.

I owe a huge debt of thanks to my husband, Robert Barth, one of the most supportive men I have ever known and a great proofreader.

# INTRODUCTION

The first volume of *The Delaware and Raritan Canal* focused on the life of this great waterway from its construction in the early 1830s, through its successful life as a freight carrier, to its rebirth as a park in the late 20th century. This second volume, *The Delaware and Raritan Canal at Work*, introduces the reader to the many businesses that operated along the waterway, the nuts and bolts of canal operation, and the varied vessels that cruised its waters. In addition, a then-and-now chapter compares current and historic views at many locations along the canal.

For centuries, the narrow "waist" of New Jersey has been a transportation corridor. The Lenape Indians followed trails across the state to harvest seafood along the shore. The earliest stage routes traversed this right of way between New York and Philadelphia. Here, too, the Camden & Amboy Railroad first laid its track between Bordentown and South Amboy. Since this was the flattest and easiest crossing of the Garden State, it was natural that canal supporters proposed this route for a waterway.

The Delaware and Raritan Canal, a 44-mile-long artificial waterway, crossed New Jersey, connecting Philadelphia and New York. To avoid the longer ocean voyage around Cape May, boats entered the canal near Bordentown on the Delaware River. Traveling north through seven locks, the vessels were lifted 58 feet to the summit (the highest point of the canal) in Trenton. Seven more locks lowered the boats to tidewater at New Brunswick on the Raritan River.

If the canal flowed past your door, you were connected to the world. Canalboats took you to the ports of Bordentown and New Brunswick. From there, you boarded a steamboat to the harbor at New York or Philadelphia, and then an oceangoing vessel that sailed the seven seas. As part of the Intracoastal Waterway, the Delaware and Raritan Canal connected the Chesapeake Bay with New England ports. As a result, a wide variety of vessels used the canal to avoid the dangers of the Atlantic off the New Jersey coast. Vessels using this shortcut included steam freighters, tugboats, yachts, powered pleasure craft, the *Holland VI* submarine, the captured Spanish gunboat *Alvarado*, sailing sloops, and, of course, mule-drawn canalboats.

The business of the canal was to serve business. All along the route, canalboats delivered Pennsylvania anthracite coal to factories, homes, and coal yards in New Jersey, New York harbor, and points north and south. They brought farm products to market, carried store-bought goods to residents in the interior, delivered raw materials to the factories, and distributed finished products to outlets throughout the region. Businesses along the canal included food-packing companies, rubber-reclaiming plants, distilleries, coal yards, quarries, lumberyards, pharmaceutical plants, terra cotta potteries, wallpaper manufacturers, and farms.

From its opening in 1834, the Delaware and Raritan Canal was a commercial success. Due to the Civil War and the expansion that followed it, the 1860s and 1870s were the most profitable years for the waterway. In fact, in 1866, a record 2.99 million tons were shipped through the waterway—more tonnage than was carried in any single year on the much longer and more famous Erie Canal.

Anthracite coal was the chief cargo transported. It was shipped from the coal fields of northeastern Pennsylvania to Easton via the Lehigh Canal, or to Philadelphia via the Schuylkill Canal. From Easton, boats then proceeded south on Pennsylvania's Delaware Canal to the outlet lock just below New Hope and crossed the Delaware River on a cable ferry. The river's current carried the boats across in either direction. From Philadelphia, canalboats were towed up the Delaware River to enter the Delaware and Raritan Canal at Bordentown.

Other goods shipped on the canal included wire rope, paint, wallpaper, lumber, brick, gin, terra cotta, pharmaceuticals, rock, and farm products.

The unusual machinery of the Delaware and Raritan Canal—locks, swing bridges, aqueducts, spill gates—is depicted in detail in this volume. It was one of the few towpath canals to use swing bridges. The A-frame mechanism allowed the bridgetender to easily push the bridge to the side, halting road traffic and allowing canalboats to pass. Early in the 20th century, the A-frame was replaced by the kingpost type; this bridge provided stronger support for the increasingly larger and heavier vehicular traffic.

Like other canals, the Delaware and Raritan has aqueducts, water-filled bridges that carry the canal over a stream, valley, railroad, or road. In Plainsboro, the Millstone Aqueduct crosses the Millstone River. Six stone columns support a semi-watertight wooden trunk. In Trenton, aqueducts carry the canal over Parkside Road and Hermitage Way. Another aqueduct in Trenton carries the canal over the Pennsylvania Railroad's main line. Two smaller structures take the canal across the Alexauken and Swan Creeks.

The Delaware and Raritan experienced changes almost from its inception. By the 1850s, chief engineer Ashbel Welch ordered that the banks be lined with riprap (stone) to prevent erosion from the wakes of steam canalboats and tugs. Lock chambers were lengthened from 110 feet to 220, and the canal was deepened to 8 feet. In 1868, "mechanical mules" were installed at all locks on the main canal to speed up the locking process.

The Delaware River is the major source of water for the canal. A 22-mile-long feeder was dug parallel to the river to supply water to the main channel. At Bulls Island (Raven Rock), a wing dam diverts water into the feeder. The water then flows downstream and joins the main canal in Trenton, providing enough water to fill the canal's 44 miles. In addition to being a water conduit, the feeder was navigable by canalboats. Traffic on the feeder greatly increased after changes were made in the 1840s, allowing boats to cross the Delaware and enter the canal at Lambertville.

Finally, the "Then and Now" chapter shows historic photographs and their corresponding current views in the Delaware and Raritan Canal State Park and in New Brunswick. Some look the same; others are unrecognizable. Trees have grown up along the path where, historically, they were not allowed to grow. Modern dwellings have replaced old hotels and canal structures, and parking areas have been created where canal folk once visited or shopped.

These chapters display nearly 200 new views of the famous Delaware and Raritan Canal, one of the most successful towpath canals in the United States.

# One

# AN OVERVIEW

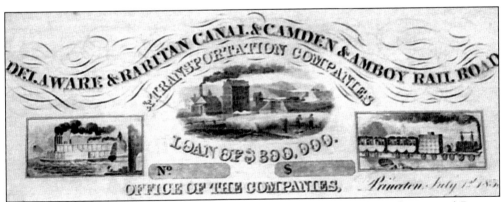

On February 4, 1830, the state legislature granted one charter to the Delaware and Raritan Canal Company and a second to the Camden and Amboy Railroad. After three days of stock sales, only 1,134 of the required 5,500 canal company shares had been subscribed. The railroad, however, was fully subscribed in 10 minutes. With the charter in danger of being invalidated, Robert F. Stockton, of Princeton, convinced his father-in-law, John Potter, to fund the remaining 4,800 shares, validating the charter. The "Marriage Act," passed in 1830, created the Joint Companies, a merger of the Delaware and Raritan Canal and the Camden and Amboy Railroad. Pictured is a banknote for $300,000, printed from the original copperplate, now in the National Canal Museum archives. The artist has taken some license, depicting the canal in an unnamed city with two imaginary locks. (Courtesy of the National Canal Museum.)

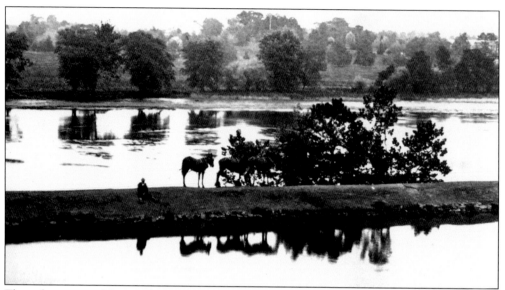

Throughout most of the canal's 98 years of operation, mules were used to tow canalboats. Although steam-powered vessels navigated the waterway from the mid-1800s, mules and sometimes horses continued to be used. In pairs or teams of three and four, these sturdy animals plodded along the dirt towpath for 44 miles, pulling loads of more than 80 tons. Here, the mule driver fishes while the vessel (out of view) is tied up nearby. In the final years after World War I, steam-, gasoline-, and diesel-propelled craft were mainly used. (Courtesy of the Canal Society of New Jersey.)

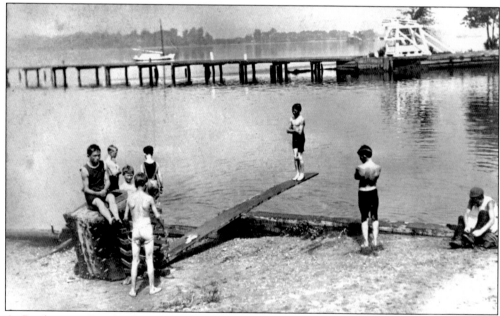

At Bordentown Beach, along Crosswicks Creek, several youngsters enjoy a cool dip. Across the water is the pier that guided boats into Lock No. 1 and provided a place to tie up while awaiting entry. The white structure is the mechanical mule, designed by chief engineer Ashbel Welch to winch nonpowered vessels into and out of the locks more quickly. (Courtesy of the Canal Society of New Jersey.)

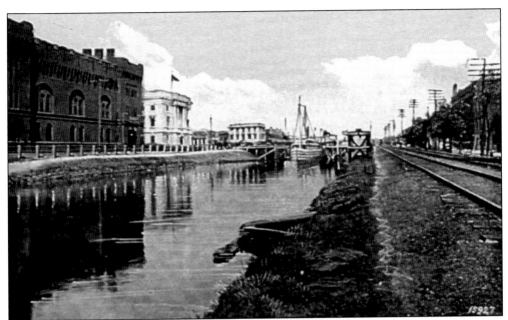

This view looks upstream toward the State Street lock (Lock No. 7), in the heart of industrial Trenton. The canal served the many potteries and other manufacturing facilities in the state capital. The Pennsylvania Railroad, which paralleled the canal in the city, can be seen on the right. The first building on the left is the armory; the next is city hall.

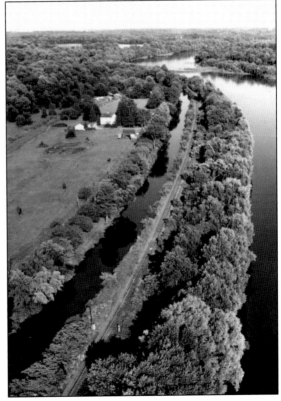

When engineers plan the construction of a canal, the most important consideration is the source of water: a lake or a river. For the Delaware and Raritan Canal, that source was and still is the Delaware River. At Bulls Island, north of Stockton, a wing dam diverts river water into a feeder canal, beginning a 22-mile journey south to Trenton and the junction with the main canal. This aerial view shows the feeder paralleling the Delaware River (right). (Courtesy of the Canal Society of New Jersey.)

11

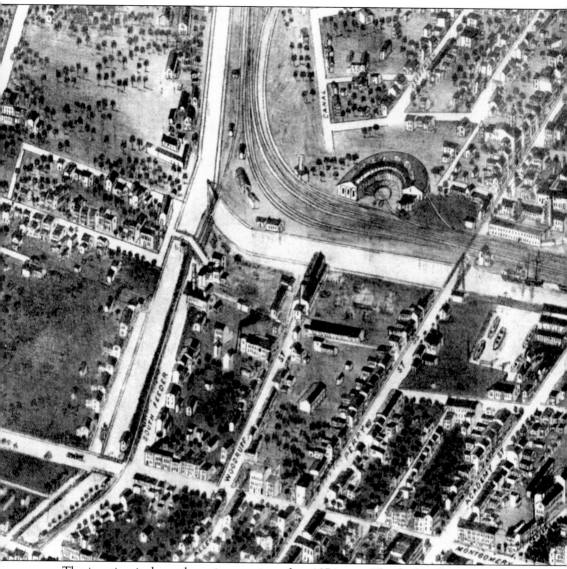

The junction is shown here, in a section of an 1874 map. The feeder, flowing north to south (bottom to top) on the left side of the map, joins the main canal in downtown Trenton, near today's Old Rose Street. The huge roundhouse of the Pennsylvania Railroad dominates the Coalport Yards. Just downstream on the right, boats await their cargo in a rectangular basin that has since been filled in to form a parking lot. At this junction today, the watered feeder is visible, but the main canal flows in a conduit under Route 1 for about a mile. The canal is uncovered again at Mulberry Street. In the near future, a walking path will be constructed along Route 1 to make the trail continuous. (Courtesy of Hunter Research.)

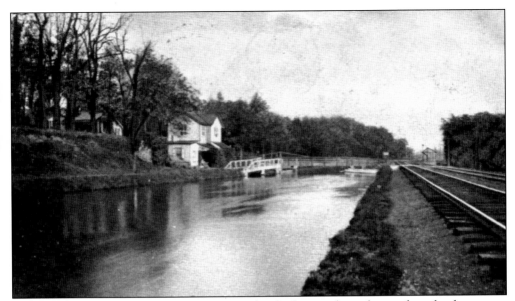

Mule-pulled boats were generally found on the feeder canal, as the six-foot depth was too shallow for many of the larger, steam-powered vessels. On the left is a portion of Trenton's Cadwalader Park, designed by noted landscape architect Frederick Law Olmsted. The tracks on the right carried the Belvidere-Delaware branch of the Pennsylvania Railroad. The railroad was built on the original towpath, and the towpath was moved to the berm bank (the side opposite the towpath). It was never leveled or graded. This view is looking south toward the junction in Trenton.

Over its 44-mile course, the Delaware and Raritan Canal passed through few towns and cities. More often, the boatman's view was one of rural countryside and scenic farms. Early Dutch settlers, drawn to Somerset County by the fertile land along both the Raritan and Millstone Rivers, established many of these farms. Seen here are typical farm buildings along the canal in East Millstone. Note the loading doors in the side of the big barn; they facilitate loading directly into a canalboat. (Courtesy of the Franklin Township Public Library.)

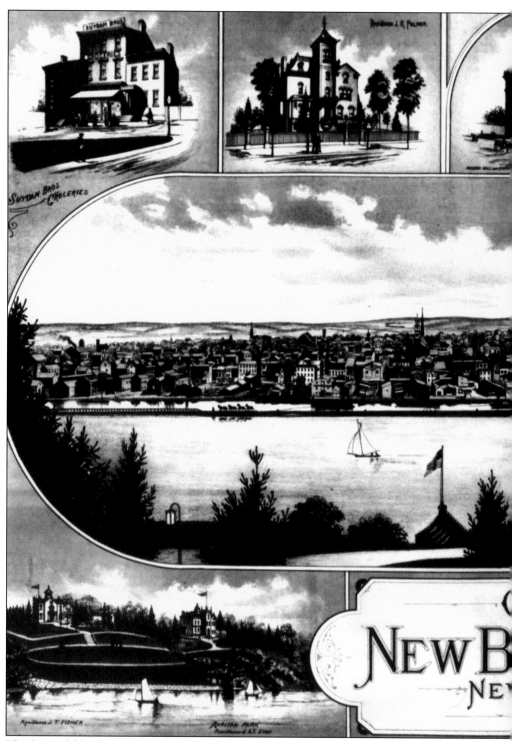

This beautiful bird's-eye view of New Brunswick shows the harbor of the Delaware and Raritan Canal on the far side of the Raritan River. Many factory buildings line the bank of the canal in this once industrial city. The harbor extends from the outlet locks (out of sight to the left),

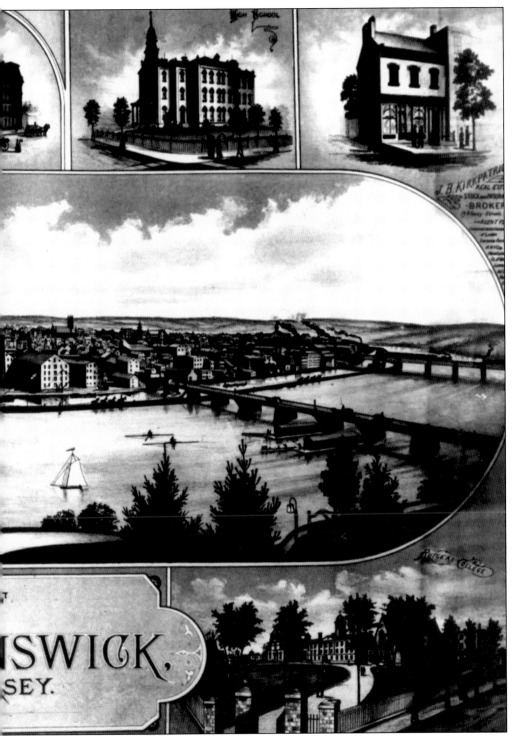

under the Albany Street bridge, to Lock No. 13, just beyond the Pennsylvania Railroad bridge in the distance. A team of four mules can be seen on the towpath at the left. (Courtesy of the Canal Society of New Jersey.)

NEW BRUNSWICK, N. J.
COMMEMORATES
THE DELAWARE AND RARITAN CANAL CENTENNIAL
AND THE STEVENS CENTENNIAL OF TRANSPORTATION
PROGRESS IN NEW JERSEY
OCT. 11 - 12 - 13 - 1934

1834      1934

100 YEARS of PROGRESS

The canal terminated in New Brunswick. In 1934, the city issued a first-day cover to commemorate the Delaware and Raritan Canal Centennial and the Stevens Centennial of Transportation. John Stevens (1749–1838) headed a family of inventors. In 1811, Stevens operated the first steam ferry between New York City and Hoboken, but due to the monopoly of Robert Fulton, he soon stopped. Later, focusing on railroads, Stevens received from New Jersey the first railroad charter in the United States, in 1815. (Courtesy of the Franklin Township Public Library.)

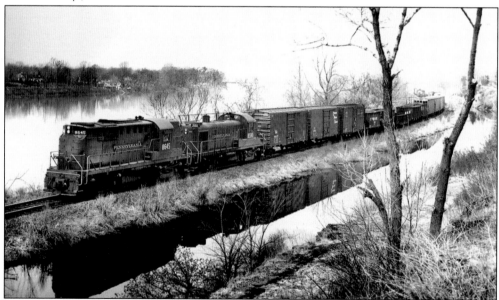

By the 1860s, the Delaware and Raritan Canal was one of the most commercially successful towpath canals in the nation. Toward the end of the 19th century, however, railroads began to carry more freight. In 1871, the Pennsylvania Railroad leased the Joint Companies for 999 years. From then on, the canal steadily declined, showing its first net loss in 1893. It was never operated profitably again. Shown here is the Belvidere-Delaware Railroad branch along the canal feeder, next to the Delaware River. (Courtesy of the Delaware and Raritan Canal Commission.)

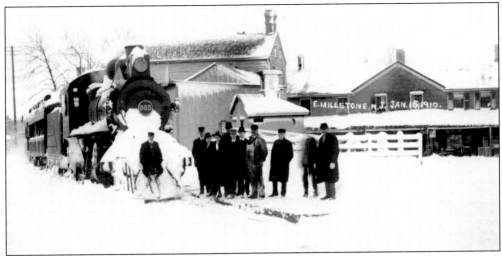

The main reason for the canal's decline was competition from the railroads, which were much faster and operated both day and night; the canal closed from roughly 10:00 p.m. to dawn. Also, trains ran all year, as shown by this 1910 photograph. The canal, however, was closed from December to April. The waterway could close even before the water froze, if the towpath became too slippery for mules to get traction. (Courtesy of the Franklin Township Public Library.)

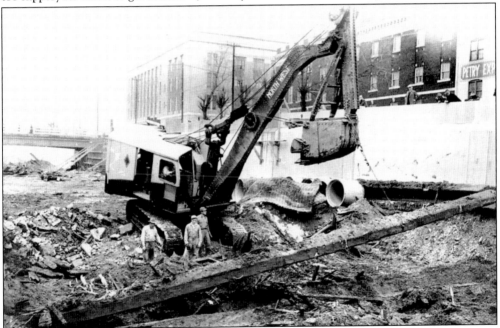

In the 1920s, as commercial traffic lessened, pleasure-boat traffic nearly doubled. Unfortunately, the income from these tolls was not sufficient to overcome the loss of the freight business. The canal did not reopen for the 1933 season. In 1936, the Trenton portion was deeded to the city and filled in as a Works Progress Administration (WPA) project. Later, it was excavated (as shown above) to build Route 1. The charter called for forfeiture to the state if the canal failed to operate for three consecutive years. Thus, in 1937, with 933 years left on its lease, the Pennsylvania Railroad ceded the canal to the state, which declared it abandoned. (Courtesy of the Delaware and Raritan Canal Commission.)

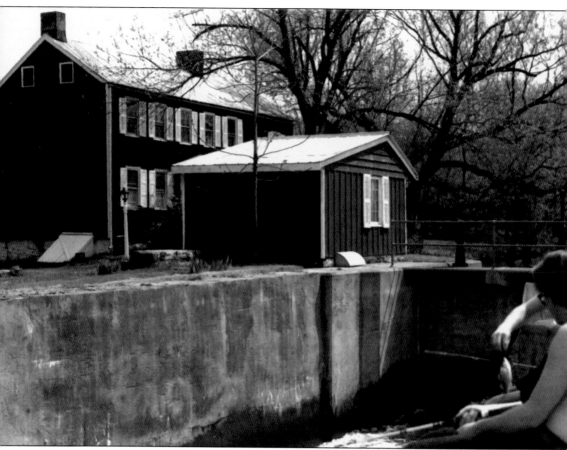

Today, the Delaware and Raritan Canal is both a drinking-water supply and the premier recreational greenway of central New Jersey. Established in 1974, the Delaware and Raritan Canal State Park provides much-needed open space in this, the most densely populated state in the nation. Visitors come to jog, stroll, ride horses, fish, paint, canoe, cross-country ski, bike, or just walk the dog. (Courtesy of the Canal Society of New Jersey.)

# *Two*

# THE NUTS AND BOLTS

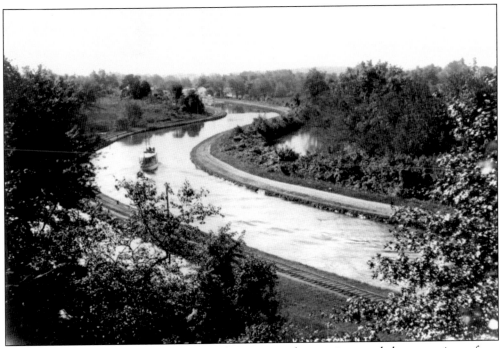

What is a towpath canal? It is a man-made waterway that carries vessels between rivers, from the interior to the coast, or around rapids or other obstacles. The goal of the engineers is to build the canal on the most level terrain, using the minimum number of locks or inclined planes to overcome the necessary changes in elevation. In the early days, the "ditch" was dug by hand, using picks and shovels, as well as animals to drag scoops and move loads of dirt. (Courtesy of the Historical Society of Princeton.)

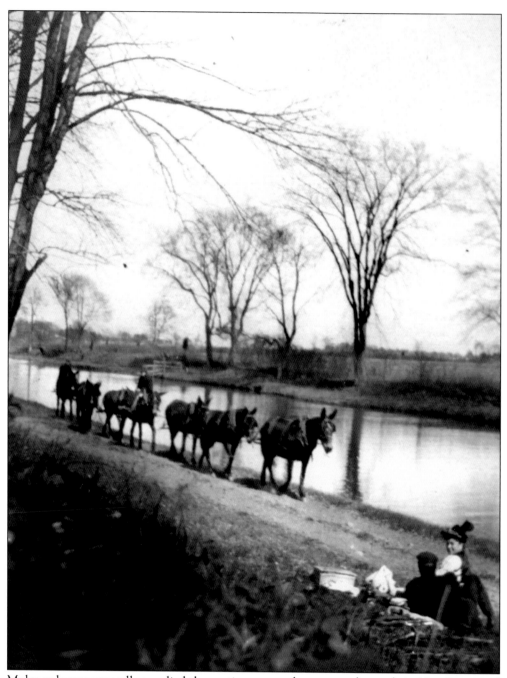

Mules or horses generally supplied the motive power along towpath canals in New Jersey and Pennsylvania. Teams of two, three, or four animals, harnessed together, walked along the towpath, pulling the canalboats. The towline was more than 100 feet long, so the mules were quite far ahead of the boat. Usually, a mule driver walked with the team to keep them moving and to respond quickly to problems. (Courtesy of the Historical Society of Princeton.)

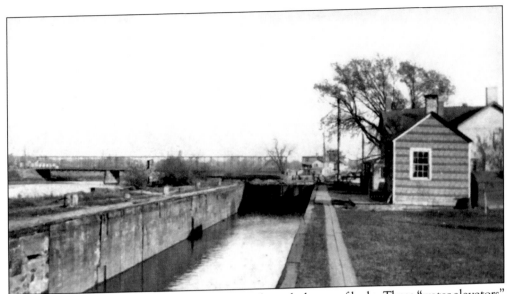

Canals typically overcome changes in elevation through the use of locks. These "water elevators" are stone, wood, or concrete chambers with gates at each end. By letting water in or out of the lock, the locktender raises or lowers the vessel to the next level section of canal. (Courtesy of Clara Higgins.)

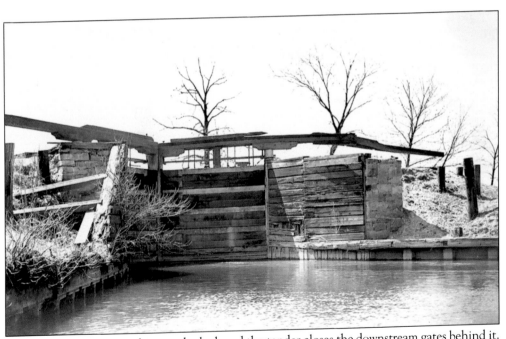

Headed upstream, a vessel enters the lock and the tender closes the downstream gates behind it. Most often, these are wooden miter gates that close at an angle; the pressure of the rising water keeps them closed. Here at the Griggstown lock (Lock No. 9), the miter gates are closed. The long balance beam supports the weight of the gate and provides leverage when the locktender opens or closes the gates. (Courtesy of the Franklin Township Public Library.)

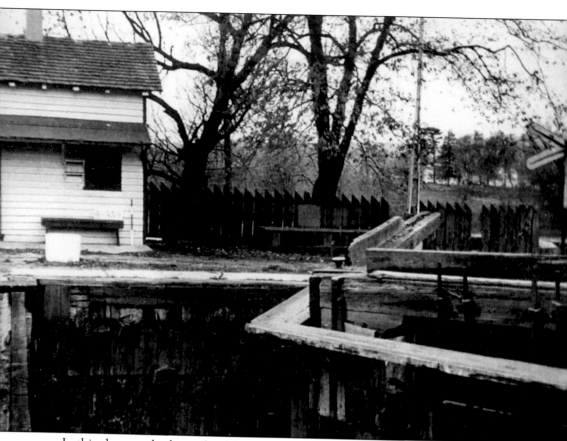

In this photograph, the angle of the miter gates is easier to see. To prepare the lock for a vessel coming upstream, the tender walks out onto the narrow plank at the top of the gates. Using a lever, he turns the vertical bars and opens the wickets, small doors near the base of the gates, allowing water to flow out. For an upstream journey, this would be done before the vessel enters. The cast-iron crossbuck is a grade crossing sign for the Rocky Hill branch of the Pennsylvania Railroad. (Courtesy of the Delaware and Raritan Canal Commission.)

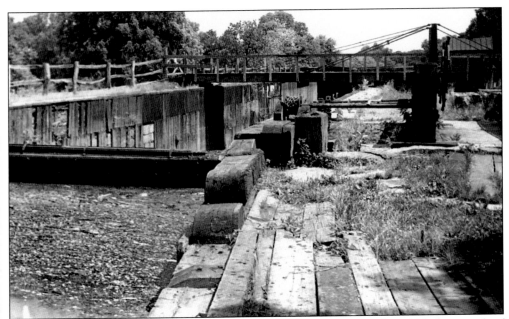

At the upstream end of the lock, a drop gate holds back the water. In this 1925 photograph of Ten-Mile Lock (Lock No. 10), the drop gate is in the upright position, creating a dam to hold back the water. To raise the vessel in the lock, the tender walks to the upstream end. Using the winching mechanism shown in the center, he opens the wickets (below the gate), allowing water to fill the lock. (Courtesy of the Canal Society of New Jersey, Cawley Collection.)

The canal's woodwork was, for the most part, massive and fashioned on site by hand. The hand-forged metal parts were simple in design but practical. The hinge post is attached to the lock gate (lower left) and to the lock wall (right). The post is the pivot for the gate. (Note: the balance beam has been removed.) In the Griggstown lock photograph on page 21, the hinge post is visible on the right side of the gate. (Courtesy of the Canal Society of New Jersey, Cawley Collection.)

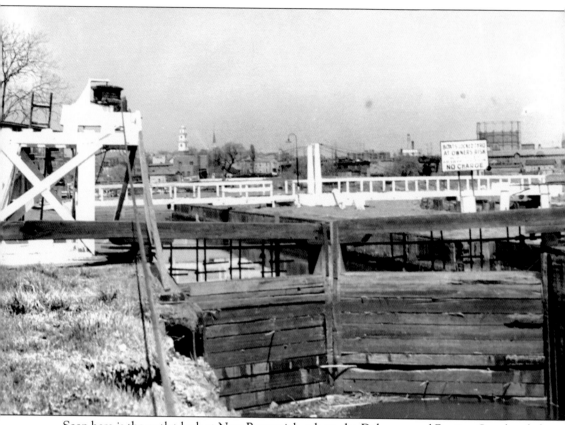

Seen here is the outlet lock at New Brunswick, where the Delaware and Raritan Canal ended at the Raritan River. The miter gates are closed, and the lock is empty; that is, most of the water has been let out. The lock is ready for the next upstream boat. Taken in 1930, this photograph shows the "mechanical mule," invented by chief engineer Ashbel Welch. This device used a continuous loop cable that winched boats into and out of the lock more efficiently. At the lower left, the cable extends from the "mule" toward a boat. The cable was manufactured at the Roebling Works in Trenton. (Courtesy of the Canal Society of New Jersey, Cawley Collection.)

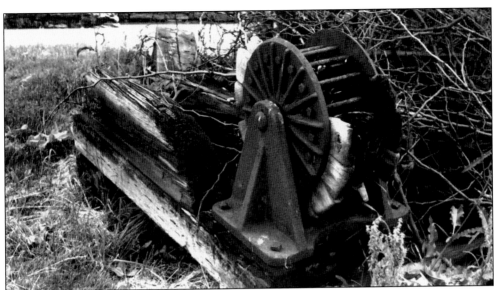

Mechanical mules were installed at all locks in 1868; unfortunately, their operation was not widely photographed. This pulley was part of the mechanical mule seen in the previous image. Its purpose was to return the cable to the steam engine, in much the same way as a clothesline pulley operates. Although this remnant was found on the ground, the pulley was most likely attached to a platform to keep the cable from dragging. (Courtesy of the Canal Society of New Jersey, Cawley Collection.)

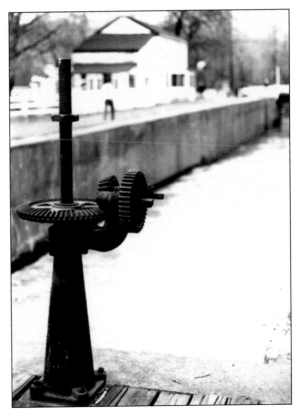

Today, the New Jersey Water Supply Authority operates the canal as a water supply system, maintaining the locks, culverts, spillways, and other structures to ensure a steady flow of water to its customers. The drop gates have been replaced with concrete dams and iron sluice gates to control the amount of water released downstream. (The miter gates have been removed since they are no longer necessary.) The operator uses this mechanism to raise and lower the sluice gates in order to increase or decrease the flow of water. The gates are operated by a hand crank, which turns a bevel gear attached to a threaded stem mounted on a stanchion or pedestal. Thus, the locks now function essentially as flow-control structures. (Courtesy of the Canal Society of New Jersey, Cawley Collection.)

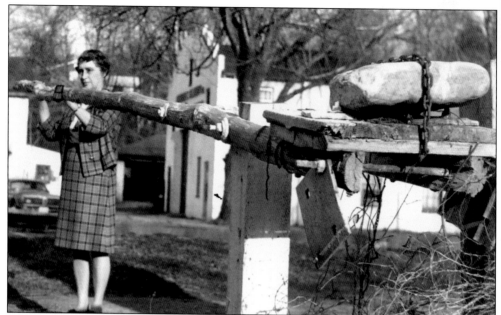

In this 1968 photograph, Margaret Cawley stands next to the only surviving original towpath gate, which was at the Kingston lock. These gates were lowered to prevent other boats' mule teams from entering the area before the lock was cleared and the toll paid. (Courtesy of the Canal Society of New Jersey, Cawley Collection.)

On a visit to New Jersey, Joseph Stellato, director of waterways maintenance (including the Erie Canal) with the New York Department of Transportation, stands at the entrance to Lock No. 14 (the outlet lock) in New Brunswick. Behind Stellato is an abutment that separated the two locks and guided vessels into and out of the chambers. Today, this entrance is blocked by a cofferdam. (Courtesy of the Canal Society of New Jersey.)

THE DELAWARE AND RARITAN CANAL, New Jersey

The Delaware and Raritan Canal connected the Chesapeake Bay with New England ports, allowing a wide variety of vessels to use the waterway and avoid the treacherous Atlantic Ocean. The unusual machinery of the canal—locks, swing bridges, aqueducts, spill gates—is depicted in detail in *The Delaware and Raritan Canal at Work*. The book focuses on many of the businesses that operated along the canal, including farms, food-packing companies, rubber-reclaiming plants, coal yards, quarries, Johnson & Johnson, and Atlantic Terra Cotta. It includes scenic views along this famous waterway, one of the most successful towpath canals in the United States.

For *The Delaware and Raritan Canal at Work*, Linda J. Barth selected vintage images from the Canal Society of New Jersey, the Franklin Township Public Library, and private collections. The author of Arcadia's first book on the Delaware and Raritan Canal, as well as numerous canal and travel articles, she grew up in the canal town of South Bound Brook. A longtime member of the board of the Canal Society of New Jersey, she leads tours on canals throughout the Northeast. She has also taught school and served as the curator of the Mule Tenders Barracks Museum in Griggstown.

The Images of America series celebrates the history of neighborhoods, towns, and cities across the country. Using archival photographs, each title presents the distinctive stories from the past that shape the character of the community today. Arcadia is proud to play a part in the preservation of local heritage, making history available to all.

www.arcadiapublishing.com

ARCADIA
PUBLISHING

ISBN-13 978-0-7385-3597-5
ISBN-10 0-7385-3597-4
$21.99

52199

9 780738 535975

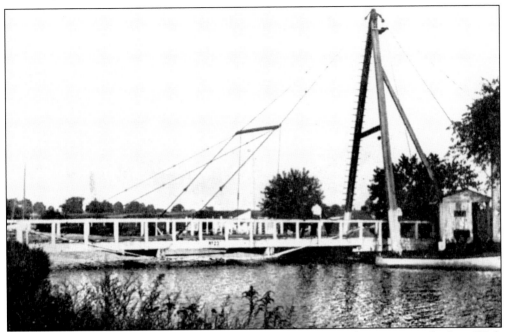

The Delaware and Raritan Canal was one of the few towpath canals to use swing bridges. With unlimited overhead clearance, canalboats, steam freighters, and even tall-masted schooners easily passed through the waterway. Perhaps someday this bridge could be made to swing again, allowing a canalboat to cruise from South Bound Brook to Weston. (Courtesy of the Pillar of Fire, Zarephath, N.J.)

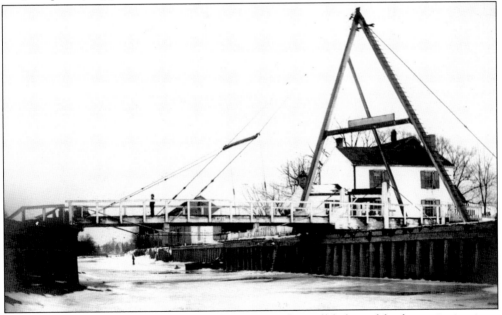

To open the span, the bridgetender pushes against the well-balanced bridge, swinging it to the side. The A-frame does not move but supports the weight as the bridge swings. The man standing on the bridge gives a good indication of the height of the A structure. (Courtesy of the Franklin Township Public Library.)

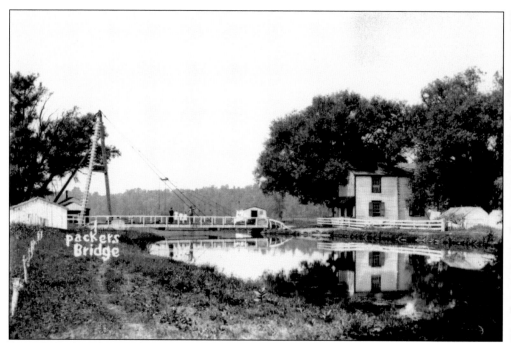

At each bridge, the canal company built a home for the tender and his family. In addition, a small hut, visible at the end of the bridge, allowed the employee a warm, dry place to wait for vessels. The family often had a garden and perhaps chickens for personal use and to supplement their income. (Courtesy of the Historical Society of Princeton.)

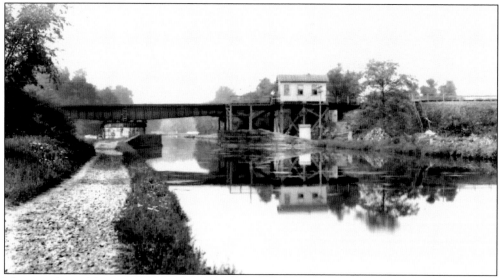

The main line of the Pennsylvania Railroad bypassed the borough of Princeton in 1865, locating its station instead at Princeton Junction. The nearly-three-mile Princeton line was built to serve the town. Known as the Dinky, it operated with an engine and a passenger car. Also called the PJ & B (Princeton Junction & Back), this popular train continues to carry commuters and Princeton University students en route to New York and Philadelphia. The rollers and gears of the swing mechanism can still be seen on this bridge. (Courtesy of the Historical Society of Princeton.)

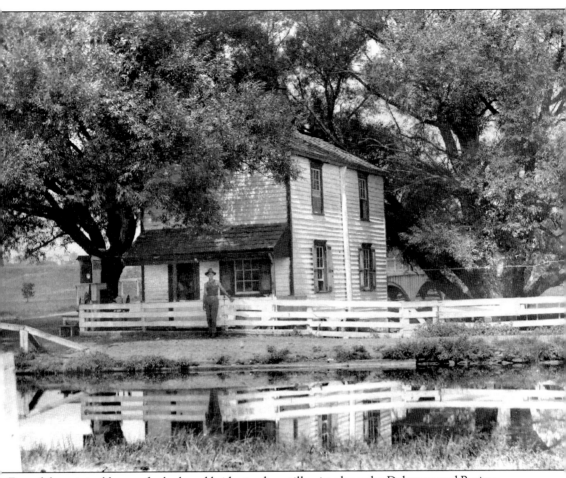

Few of the original homes for lock and bridgetenders still exist along the Delaware and Raritan. Houses can still be seen at Kingston lock, Griggstown lock and bridge, Blackwells Mills bridge, East Millstone, and Trenton. Here, at Packer's Bridge, the tender poses in front of his home, a sturdy, two-story residence with the typical picket fence. Barely visible behind the house is the arched bridge carrying Harrison Street over Lake Carnegie. (Courtesy of the Historical Society of Princeton.)

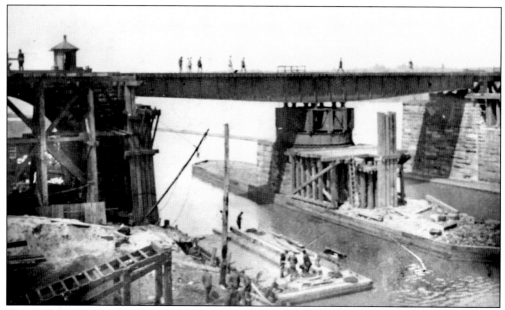

Originally, a wooden bridge carried the railroad across the canal and the Raritan River in New Brunswick. Here, the Pennsylvania Railroad constructs a steel span to replace the wooden one. This new bridge remained until 1903, when a stone-arched span was built. With no swing section, this bridge forever limits the clearance to 50 feet. (Courtesy of the Franklin Township Public Library.)

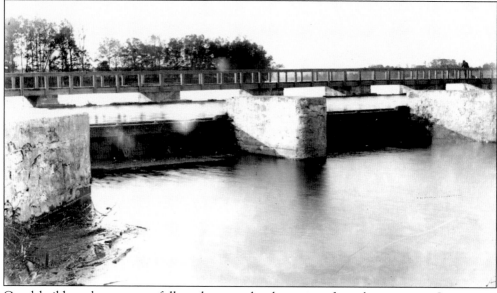

Canal builders always try to follow the most level terrain, often along a river. Sometimes, however, a railroad, stream, or valley bisects the right-of-way. To cross this obstacle "on the level," the engineers construct an aqueduct, or water-filled bridge. In Plainsboro, the canal crosses the Millstone River in a semi-watertight wooden trunk, supported on six stone pillars. This side view shows the walkway built for the mules on the towpath side. After the river was dammed to create Lake Carnegie, the water level rose to just below the trunk. (Courtesy of the Historical Society of Princeton.)

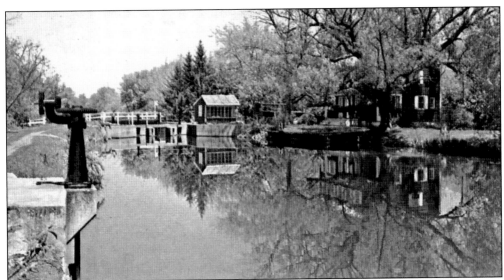

At 8 feet deep and 75 feet across at the surface, the canal was designed to hold a specific amount of water. After a heavy rain, however, it could overflow, leading to erosion and a possible rupture of the canal bank. To control the water level, engineers constructed spillways and waste weirs. Here, at Griggstown, a waste gate is located in the bank in the lower left corner. When the tender turned the black gear, using a winch handle, he raised the gate to "waste" water, allowing the excess to flow from the canal, under the towpath, and into a tributary of the Millstone River.

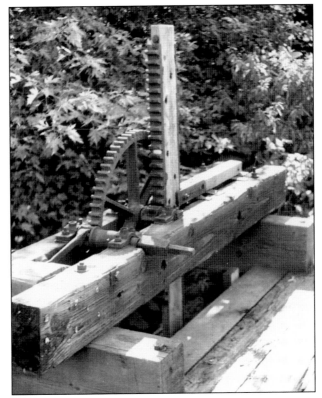

This rack-and-pinion spill gate lift is typical of many of the early devices developed for the Delaware and Raritan. By raising the vertical beam, the locktender raised the attached underwater gate and allowed excess water to flow out of the canal. (Courtesy of the Canal Society of New Jersey, Cawley Collection.)

31

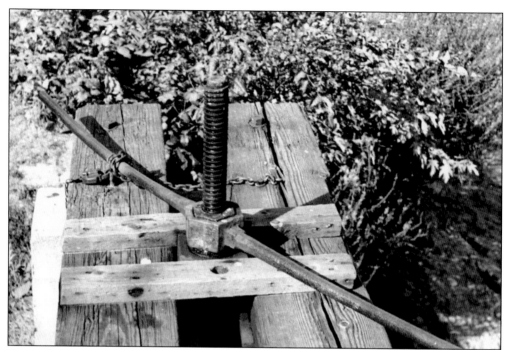

Some of the waste gates, or weirs, used this type of mechanism to raise the gate. Here, the locktender must turn the wrench to raise the screw and lift the underwater gate. (Courtesy of the Canal Society of New Jersey, Cawley Collection.)

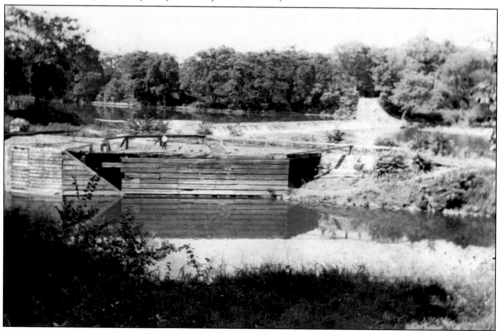

The Delaware River, through the feeder canal, supplied most of the water for the canal. For the last five miles, however, the supply was supplemented with water from the Raritan River. At the Fieldville Dam (right), water was diverted through a culvert and entered the canal just downstream of Lock No. 12 (left). (Courtesy of Margaret Milesnick.)

During the winter season, roughly from December through March, the canal company closed the waterway. The water level was lowered so that repairs could be made to bridges, locks, spillways, waste weirs, and the towpath. Of course, this provided a perfect opportunity for skating and sledding on the canal. This view looks upstream toward Lock No. 11 in South Bound Brook. One of the Ruberoid (Standard Paint) buildings appears on the left. (Courtesy of Clara Higgins.)

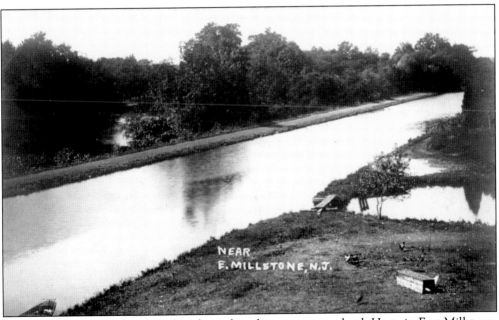

Occasionally, the canal was used to drain the adjacent swampy land. Here, in East Millstone, an opening has been made in the berm bank to allow excess water to run off of this property into the canal. There would have been a waste weir nearby to release the extra water into the Millstone River, seen in the distance. (Courtesy of the Franklin Township Public Library.)

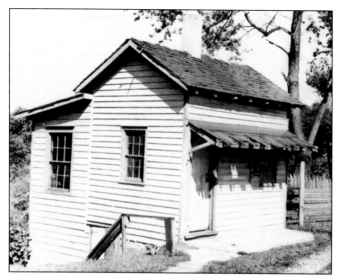

The Delaware and Raritan Canal was one of the earliest commercial users of the telegraph. The tollhouse, next to the locktender's house in Kingston, housed the telegraph office. This modern method of communication was used to report breaks in the bank, changes in water levels, and speeders who exceeded the four-mile-per-hour limit. (Courtesy of the Canal Society of New Jersey, Cawley Collection.)

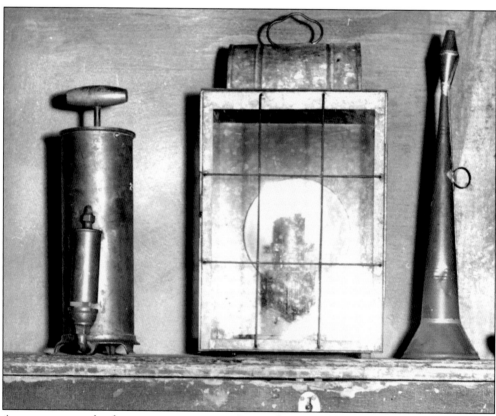

As on most canals, the captain was required to make an audible signal to alert the lock or bridgetender to his approach. Often a conch shell, a pneumatic horn (left), or a fish horn (right) was used. When cruising after dark, captains placed a night hawker, or lantern (center), on the bow. Behind the lantern, a wooden dasher (board) directed the light forward. These items are displayed at the Mercer Museum in Doylestown, Pennsylvania. (Courtesy of the Canal Society of New Jersey, Cawley Collection.)

# Three

# BUSINESSES ALONG
# THE WATERWAY

ESTABLISHED 1860.

New York, Philadelphia and Baltimore Inland

TRANSPORTATION LINE,

VIA DEL. & RARITAN AND CHES. DEL. CANALS.

We beg leave to inform our PATRONS and the PUBLIC, that in continuing our

General Inland Transportation Business,

our facilities for the SEASON OF 1874 will be such as to insure the prompt and satisfactory transmission of FREIGHT OF ALL DESCRIPTIONS, DAILY,

In the 18th century, citizens of central New Jersey traveled between Elizabethtown and Philadelphia on the Swiftsure Stage line "by the shortest, cheapest, safest, and most pleasant road" to Philadelphia, according to an 1801 newspaper advertisement. Founded in 1799, the Swiftsure charged passengers $5 for this overnight trip. Also carrying packages and freight, the line was eventually superseded by the railroad. Following a similar route, the like-named Swiftsure Transportation Line Steam Tow-Boat Company advertised its services: "Between Philadelphia and New York, via the Delaware and Raritan Canal, for the Conveyance of Merchandize, Specie, Baggage, &c." (Courtesy of the Franklin Township Public Library.)

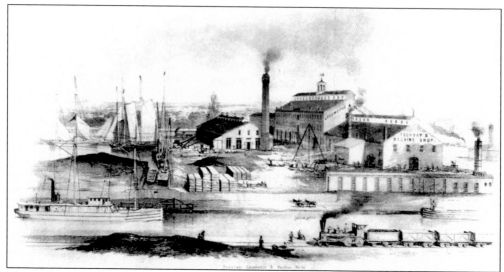

This early view of Trenton demonstrates the industrial might of the capital city, proving the truth of its motto, "Trenton Makes, the World Takes." Two vessels prepare to pass each other on the canal. Mules tow the boat on the right, as a steam freighter cruises in the opposite direction. A steam engine pulls cars on the Camden & Amboy Railroad. At the Trenton Locomotive and Machine Works, a tripod crane lifts goods, as smoke belches from the stack on the foundry and machine shop. (Courtesy of the Trenton Public Library.)

Businesses line State Street next to Lock No. 7. The dark building in the center is the lodge of the Loyal Order of Moose, nestled between the post office (white building) and Petry Express Storage Company. The advertising on the front of the Petry building states, "Movers, Packers, Shippers" at the top and "Main Office and Warehouse" above the front door. At Lock No. 7, the miter gates are closed. (Courtesy of the Trenton Public Library.)

Before opening his wire rope–manufacturing company in Trenton in 1849, John A. Roebling had already constructed the Allegheny Aqueduct for the Pennsylvania Main Line Canal. As the factory was being constructed, he was working on four aqueducts for the Delaware and Hudson Canal. His wire rope construction can be seen today on the aqueduct that crosses the Delaware River between Lackawaxen, Pennsylvania, and Minisink Ford, New York. The National Park Service restored this Roebling masterpiece in 1987. (Courtesy of Clifford Zink.)

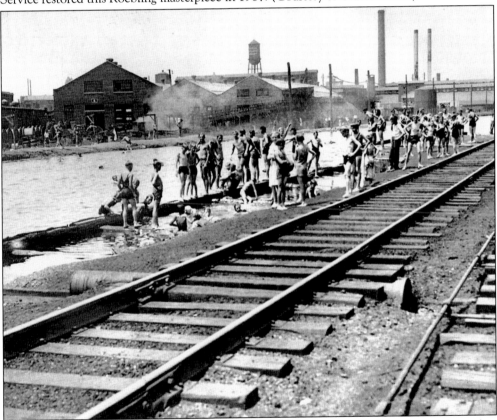

Despite the danger from boats and trains, these Trenton citizens cool off in the canal on a hot summer day in 1929. The wooden bridge fender creates a more sheltered swimming hole off the main channel. Taken from East Canal Street, this photograph shows the American Steel and Wire Company across the canal. (Courtesy of the Trenton Public Library.)

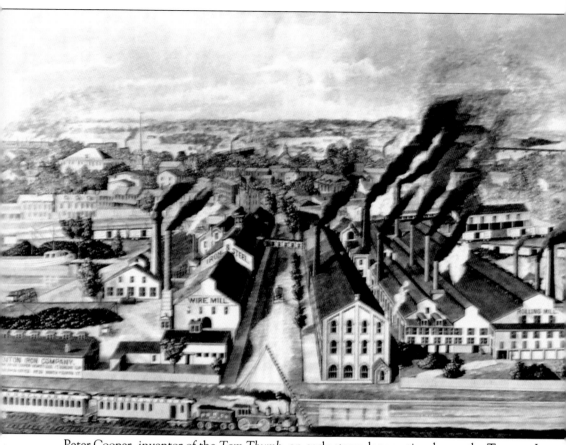

Peter Cooper, inventor of the *Tom Thumb,* an early steam locomotive, began the Trenton Iron Company in 1846. The works straddled Hamilton Avenue, the road in the center of this picture. The Camden & Amboy Railroad and the Delaware and Raritan Canal (below) provided easy transportation of Cooper's iron products. (Courtesy of Clifford Zink.)

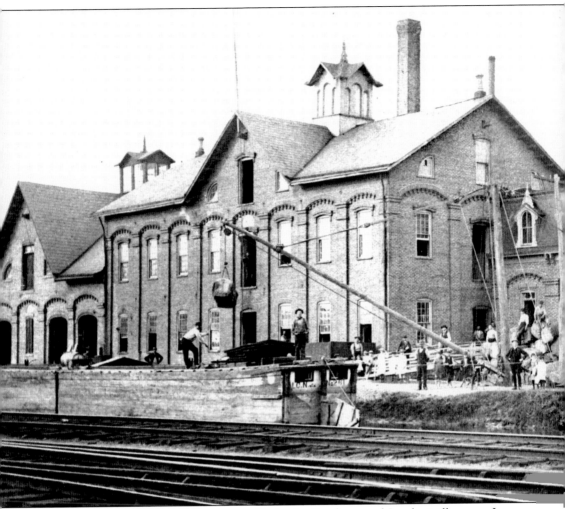

The feeder canal supported businesses, especially in the Stockton and Lambertville areas. In the latter, the Perseverance Paper Mill shipped products on both the canal (directly in front of the mill) and the Belvidere-Delaware Railroad. A gasoline-powered boom makes the work easier. The vessel is a section boat; it can be separated for ease in turning around in a narrow canal, such as the Delaware Canal or the Lehigh Coal and Navigation, both across the river in Pennsylvania. In 1923, a fire destroyed the mill. (Courtesy of the Canal Society of New Jersey.)

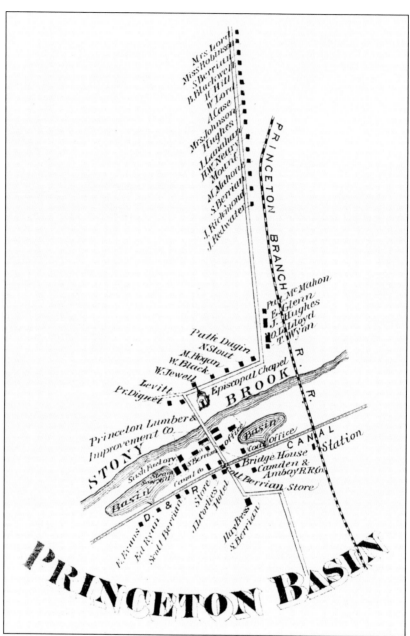

Two basins served the canallers just south of Princeton Borough, one on each side of Canal Road (now Alexander Road). Among the businesses situated around or near the basins were a sash and blind factory, Scott Berrien's General Store, Mr. Berrien's Hay Press, Fielder's Lumber and Coal, and Billy Lynch's Bottle House, advertising liquor "as cheap as any other." The Corlies Hotel was originally the Railroad Hotel. According to the Mercer County deed, "The same premises conveyed by . . . John L. Corlies by deed dated June 16, 1870 . . . Beginning at a corner of a lot of land belonging now or formerly to the estate of John C. Skillman and in a line of the Delaware and Raritan Canal and Railroad and Transportation Company." The Camden & Amboy Railroad's Princeton Junction branch, seen at the right, crossed the canal here and had a large freight depot. (Courtesy of the Historical Society of Princeton.)

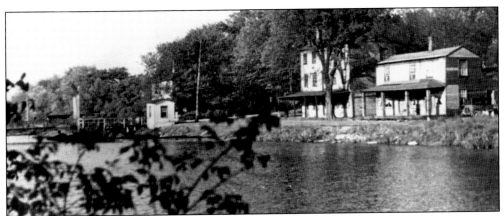

In this view, looking east across the basin, the Railroad Hotel (behind the tree) faces the canal at its junction with Canal Road (now Alexander Road). A branch of the Camden & Amboy Railroad was completed on the east side of the canal, in front of the hotel, in 1839. When the railroad relocated the tracks to Princeton Junction in 1864, the hotel was renamed the Steamboat Hotel. The small building on the left is the hut in which the bridgetender waited for vessels, and the one on the right is a store. (Courtesy of the Historical Society of Princeton.)

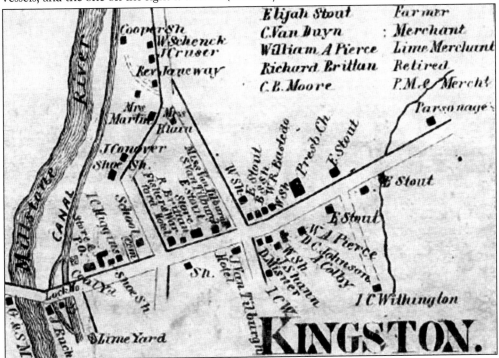

The town of Kingston is unique due to its location in three counties and three townships. A cluster of businesses developed near Lock No. 8, including a lime yard, coal yard, blacksmith, grist and sawmill (along the Millstone River), shoe shop, post office, and store. At the canal, the lock house is marked between the main channel and the bypass. Between the river and the bypass, a building is labeled "J. Buchelew." This could very well be the famous Jim Buchelew, purveyor of mules; since Kingston was close to the halfway point of the canal, this would be a good place to change mules or replace an injured animal. (Courtesy of the Franklin Township Public Library.)

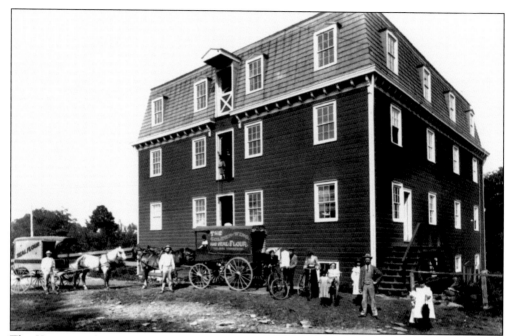

The Kingston Flour Mill used the waterpower of the Millstone River. During Gen. George Washington's march to winter quarters after the Battle of Princeton (January 3, 1777), the army dismantled and burned the bridge near the mill in order to slow the progress of the British who were pursuing the Continental forces. Tradition says that the mill was burned at this time. If so, it was certainly rebuilt soon after. When this photograph was taken in 1900, Nelson Thompson owned the Kingston Flour Mill and made the Golden Wing and Seal brands of flour. In the 1970s, Margen Penick and Charlotte Pierce successfully lobbied to prevent the destruction of the mill and the adjacent 1798 quadruple-arch stone bridge. As a result, the mill and bridge were saved. In 1986, the Kingston Mill District, including the mill and the bridge, was placed on the State and National Registers of Historic Places. (Courtesy of the Franklin Township Public Library.)

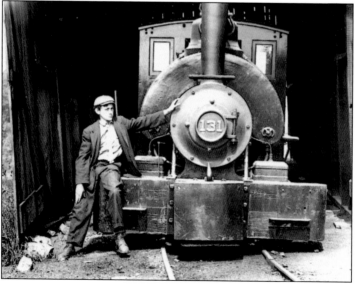

This small steam engine, one of 24 owned by the Delaware River Quarry Company, was used to transport crushed stone. After 1871, the Pennsylvania Railroad served the quarry. (Courtesy of the Franklin Township Public Library.)

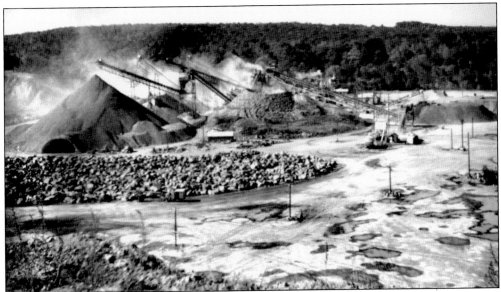

Trap Rock Industries began in the 1860s at Kingston, where paving blocks and dimension stones were mined to pave the streets of New Jersey. Today, Trap Rock is one of the largest producers of crushed stone and hot-mix asphalt in the Northeast. The company employs approximately 300 people at 4 rock quarries, 12 asphalt plants, and 1 paving division. Trap Rock maintains its headquarters in Kingston, along the Delaware and Raritan Canal. (Courtesy of the Franklin Township Public Library.)

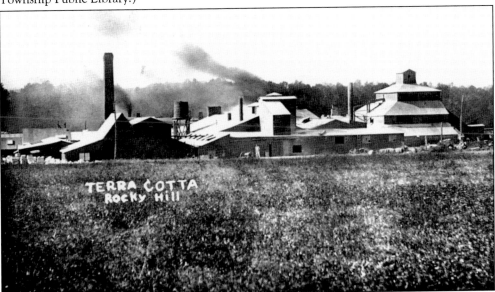

The Rocky Hill area of Franklin Township included large clay deposits, and a prime location near the canal and the railroad. In 1894, the Excelsior Terra Cotta Company built its factory on 100-plus acres along Canal Road. In 1907, Excelsior became part of the Atlantic Terra Cotta Company, the world's largest manufacturer of architectural terra cotta. Atlantic's terra cotta adorns the Woolworth Building in New York City and the Philadelphia Art Museum, as well as dozens of buildings once dubbed Manhattan's "Terra Cotta Skyline." This factory closed in 1932. (Courtesy of the Franklin Township Public Library.)

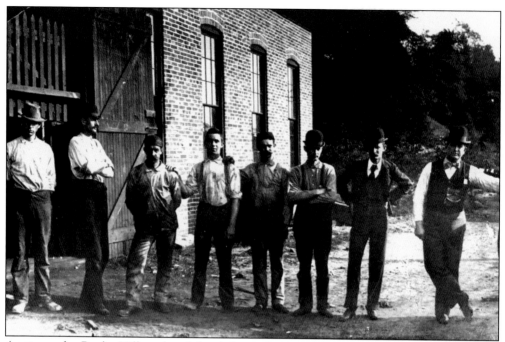

At times, the Rocky Hill works of the Atlantic Terra Cotta Company employed up to 300 workers. These artisans, many of whom were Italian immigrants, were skilled in the manufacture of glazed terra cotta, a popular building material in the late 1800s and early 1900s. (Courtesy of the Franklin Township Public Library.)

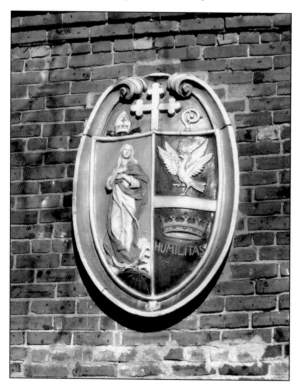

In 1919, the company purchased additional land and built a large guesthouse for visitors; it was known locally as the Terra Cotta Hotel. As the glass-and-steel skyscraper came into vogue in the 1900s, the age of terra cotta ended. The company closed in 1943. Today, only the brick powerhouse, an office building converted to a residence, and two vine-covered kilns mark the site of this once significant commercial venture along the Delaware and Raritan Canal. This medallion now graces the entrance. (Courtesy of the Franklin Township Public Library.)

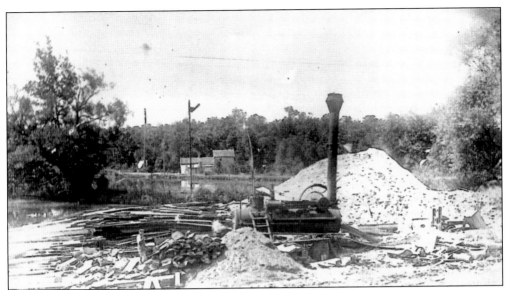

This steam boiler, with its high stack, was used to operate a portable sawmill next to the canal basin in Rocky Hill. The basin was located at the northeast corner of the present intersection of Route 518 and Canal Road. At that time, Canal Road bordered the eastern side of the basin. Finished products could be delivered easily by canalboat to the many lumberyards along the waterway. (Courtesy of the Franklin Township Public Library.)

The *Pennsylvania Gazette* of January 16, 1753, reported the presence of a valuable "copper vein of six foot square" near Griggstown, and mining shares were offered for sale *c.* 1765. Capt. John Rule of Yorkshire, England, employed Welsh coal miners to mine copper. Before the Revolution, the ore was shipped to England for smelting. After the Revolution, the mine was worked for a short time at a financial loss. In this later mining attempt, copper was shipped on the canal. Early in the 20th century, immigrant laborers worked in the reopened New Jersey Copper Company mine. This abandoned boiler likely dates from this last mining attempt. (Courtesy of the Franklin Township Public Library.)

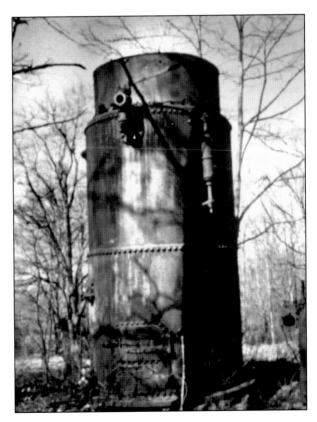

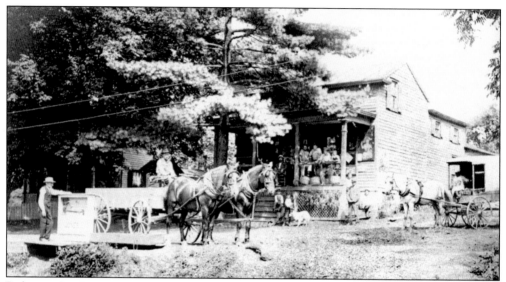

Before 1850, E. G. Beekman owned this store at the northeast corner of Canal Road and the Griggstown Causeway. In 1850, William and Caroline Oppie, with help from Cornelius Oppie, operated a general store and the post office here. Then, c. 1905, Harvey Boice sold mowers, eyeglasses, coal, grain, cider, and more. The scale in front was used to weigh the grain and coal, which was kept in a yard near the canal. A pole-and-pulley system was used to load and unload the boats. In this 1910 photograph, Boice is in the meat wagon on the scale as storekeeper Charles Cheston supervises. The building sustained heavy fire damage c. 1920 or 1921. (Courtesy of the Franklin Township Public Library.)

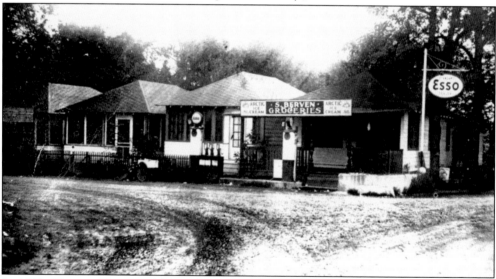

In 1927, Herman Kunze and his wife purchased several rental bungalows at Griggstown, a destination for many Norwegian-Americans from New York. The Kunzes converted one of the bungalows, located on the Griggstown Causeway at Canal Road, into a store. In 1930, Sigurd and Alice Berven bought the store and the bungalows. Edward and Rose Tornquist, later owners, sold many Scandinavian delicacies and also operated a milk route. Tropical Storm Doria closed the business for three months in 1971. Today, Steve Androsko operates a canoe concession at this site. (Courtesy of the Franklin Township Public Library.)

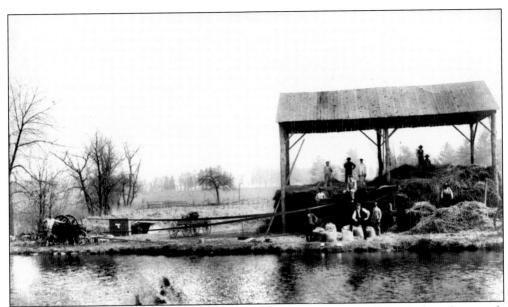

Motor-driven threshers made harvesting grain much easier. This William Tetlow photograph was taken on March 2, 1907, in East Millstone. Here, every step of the process is visible, from the beginning mountain of raw wheat to the end product (sacks of wheat and a pile of chaff). The card is postmarked 1909. (Courtesy of the Franklin Township Public Library.)

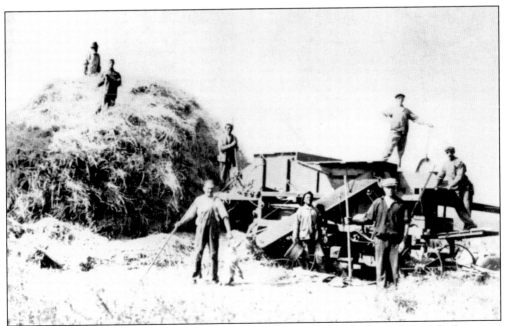

The work could now be done in the fields instead of in barns. In this photograph, a shed protects the machinery. For farms like this one in East Millstone, the canal provided easy shipping to markets in New York and Philadelphia. (Courtesy of the Franklin Township Public Library.)

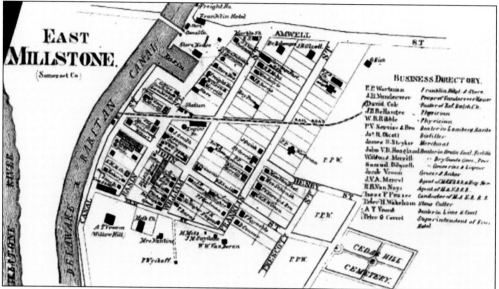

At the height of the canal's economic prosperity, a wide variety of businesses were established along or near the Delaware and Raritan Canal in East Millstone. Those closest to the canal, between Canal and Basin Streets, included the Franklin Hotel, John Vanderveer's Railroad Hotel, a lumberyard, the Olcott Distillery for "high wines," a bakery, three stores, a confectionery, a lime kiln, two blacksmith shops, a carriage factory, and the canal company office. (Courtesy of the Franklin Township Public Library.)

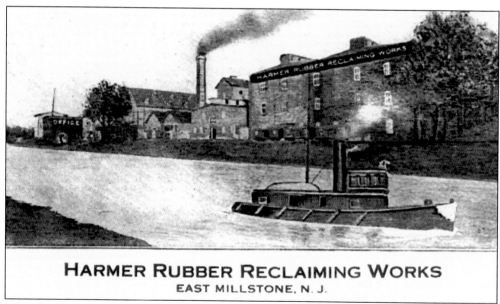

## HARMER RUBBER RECLAIMING WORKS
### EAST MILLSTONE, N.J.

After the Fleischmann Distillery burned in 1912, the Harmer Rubber Reclaiming Works, seen here from the towpath of the canal, rebuilt the factory on the site of the ruins. It later operated as the Somerset Rubber Reclaiming Works and then as the Laurie Rubber Company. (Courtesy of the Franklin Township Public Library.)

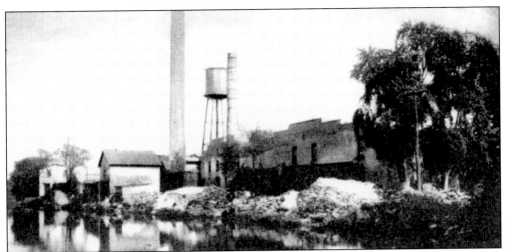

The Somerset Rubber Reclaiming Works was purchased by the Laurie Rubber Reclaiming Works. Irving Laurie served on Franklin D. Roosevelt's World War II Rubber Board. AGI Rubber Company bought the business in 1975 because Laurie held the formulas for important compounds in the rubber-reclaiming process. In the early 1980s, with several key employees gone, AGI closed. On the 2.2-acre complex, seven buildings were demolished; the last to be razed were the water tower and two smokestacks, both in 1990. (Courtesy of the Franklin Township Public Library.)

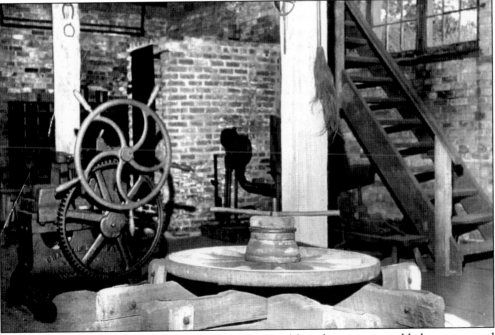

The earliest record for the Millstone Forge is 1868, although it was most likely constructed earlier. Mr. Van Cleve was the first known blacksmith here, followed by Mr. Van Nest. In 1895, Ed Wyckoff took over the business and continued for 64 years until his death in 1959. At that time, the Old Millstone Forge Association purchased the building from Mrs. Wyckoff for $2,000 and raised money for its restoration. Association members work the iron on Sunday afternoons in the spring and fall. (Courtesy of the Franklin Township Public Library.)

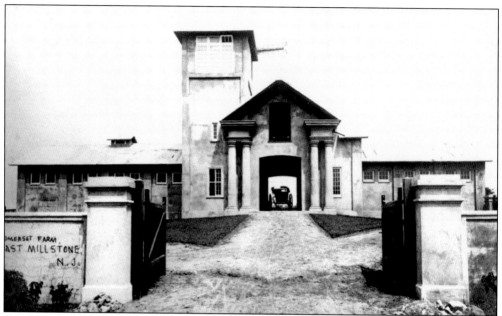

Udo Fleischmann raised and trained horses at Somerset Farm on the outskirts of East Millstone. When his original barn was destroyed by fire in 1906, Fleischmann built one of the first poured concrete buildings in the United States. In 1919, he moved to Florida and sold the farm to his brother-in-law John Wyckoff Mettler. Today, the Fleischmann stable is the only remaining building of the former estate. It is within Colonial Park, managed by the Somerset County Park Commission, and is used for the storage of vehicles and equipment. (Courtesy of the Franklin Township Public Library.)

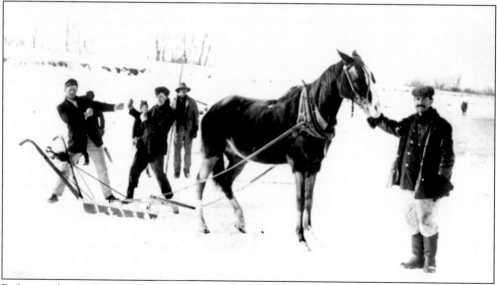

Before modern refrigeration, ice was harvested from lakes, rivers, and ponds. The quiet water of the canal froze deeper, making for thicker ice. These gentlemen enjoy a bit of fun during this break from scoring and sawing the ice and then dragging the heavy blocks to a chute. (Courtesy of the Franklin Township Public Library.)

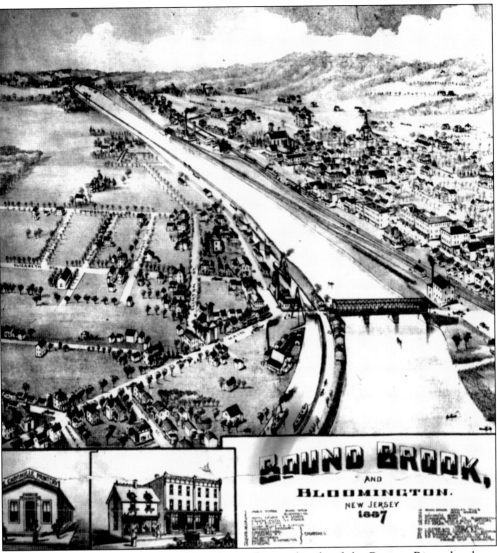

Since its founding in 1688, Bound Brook, on the north side of the Raritan River, has been an important crossroads for road traffic. With the arrival of the Delaware and Raritan Canal, South Bound Brook, across the river, soon became a transportation center, too. Sometimes referred to as "Bound Brook, south of the Raritan," this busy freight port experienced a name change in 1869. The citizens successfully petitioned the state legislature to charter the village as the town of Bloomington. The people had a change of heart 12 years later, however, and the name was changed back to South Bound Brook. One reason was the existence of 16 other Bloomington post offices, causing "much confusion, delay, and annoyance." The Bound Brook Iron Works can be seen just above the A-frame structure of the swing bridge, with Standard Paint just below the span. (Courtesy of the Canal Society of New Jersey.)

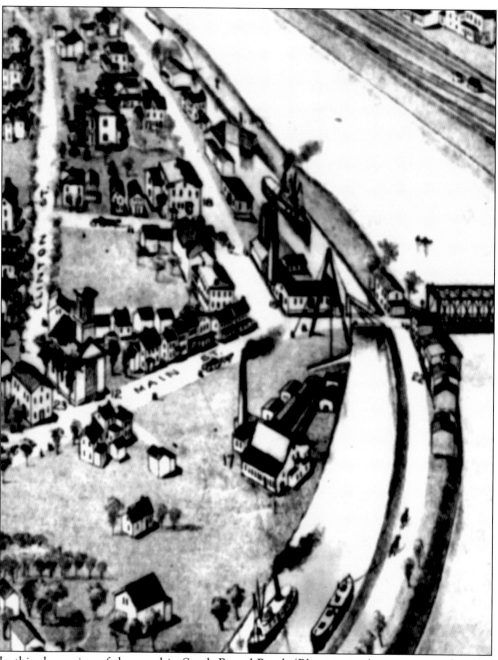

In this closer view of the canal in South Bound Brook (Bloomington), one can see the inlet at the Standard Paint Company, just south of the swing bridge. This slip allowed vessels to load and unload without blocking the main channel. Across the canal, on the towpath, is the complex of the E. B. Randolph Bottling Works. Tappan Lumber and Coal is across Canal Road, opposite the lock (above). (Courtesy of the Canal Society of New Jersey.)

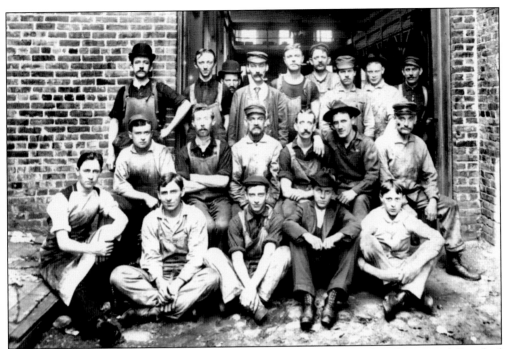

In *The Borough of South Bound Brook, A History*, H. Kels Swan notes that the original Standard Paint Company produced asphalt paints, lacquers, and insulating tapes. In 1892, the company created the first roll of ready-to-lay asphalt roofing. Because of its similarity to rubber (in appearance and water resistance), this roofing material was called Ruberoid. The product was so successful that, in 1921, the corporate name was changed to the Ruberoid Company. These workers have gathered for a company photograph. (Courtesy of Dennis Quinlan.)

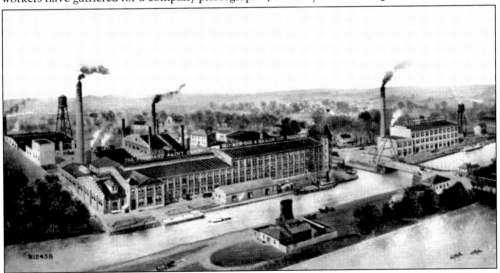

By the mid-1960s, the company employed more than 400 men and women. Raw materials were brought in via the canal until its closing in 1932. A railroad bridge built across the Raritan River and the canal also provided freight service to the company. Later, Ruberoid was purchased by GAF. The buildings were demolished in 2004 to make way for a multiuse development with a waterside promenade, shops, and housing. (Courtesy of Robert Canfield.)

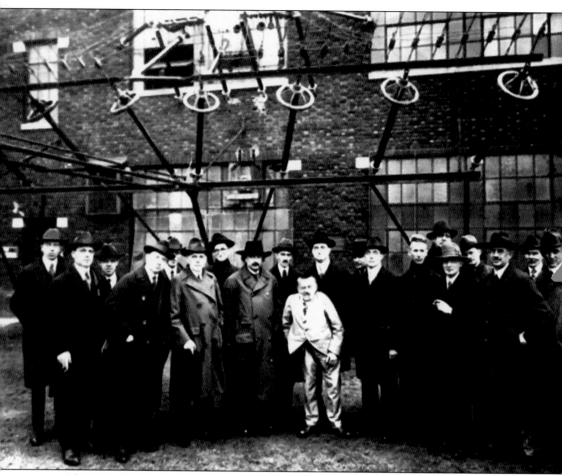

After World War I, the old New Brunswick Marconi Wireless station, along the canal in Franklin Township, became part of the newly organized Radio Corporation of America (RCA) under the World Wide Wireless logo. RCA's David Sarnoff conducted an inspection tour of the facility in 1921. Some of the greatest scientists of the era attended. Pictured from left to right are three unidentified men, David Sarnoff, Thomas J. Hayden, Ernst Julius Berg, S. Benedict, Albert Einstein, Nikola Tesla, Charles Proteus Steinmetz, A. N. Goldsmith, A. Malsin, Irving Langmuir, Albert W. Hull, E. B. Pillsbury, Saul Dushman, Richard Howland Ranger, George Ashley Campbell, and two unidentified men. The unidentified scientists may include John Carson and Ernst Alexanderson. Others may be station engineers like Hayden. (Courtesy of the Franklin Township Public Library.)

In this closer view of the canal in New Brunswick, the vessel on the far right is heading toward the end of the canal at the outlet locks. The mules prepare to step onto a wooden bridge that crosses a waste weir. This weir is a controlled opening in the towpath through which excess water is allowed to flow into the Raritan River. When the outlet locks were restored in 1998, this bridge was not re-created. As one walks upstream from the locks today, the towpath ends at the weir; a pedestrian bridge carries strollers back to the mainland. (Courtesy of the Canal Society of New Jersey.)

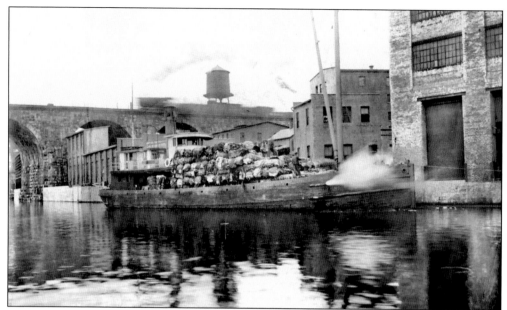

Robert Wood Johnson sought a practical application of the theory of antisepsis. With his brothers, he began the surgical dressings industry in New Brunswick in 1886 in an old factory along the Delaware and Raritan Canal. Starting with medicinal plasters, the company soon designed soft absorbent cotton and gauze dressings that could be mass-produced and shipped to hospitals, physicians, and druggists. Here, the steam canalboat *Frank M. Reilly,* loaded with cotton for those products, is moored at the J & J dock. (Courtesy of Johnson & Johnson.)

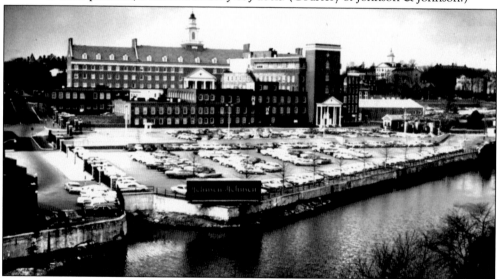

At the J & J headquarters on the canal, Fred B. Kilmer was the company's scientific director for 45 years. In 1890, in response to a doctor's complaints of patient skin irritation caused by the company's plasters, Kilmer suggested sending the patient a container of Italian talc to soothe the skin. Soon, the company began packaging the talc with the plasters; customers began asking for more of the powder. In a very short time, the scented talc was being sold as Johnson's baby powder, which remains one of the most recognized products in the world. (Courtesy of Johnson & Johnson.)

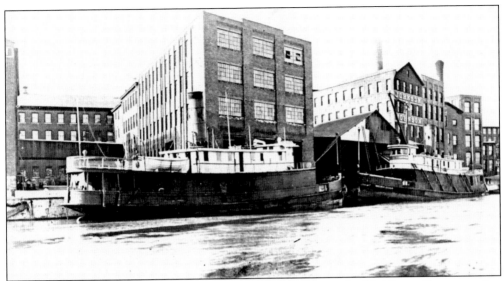

For many years, the company had its own fleet, operating as the Middlesex Transportation Company, to bring in raw materials and carry out its finished products. On this day, two steamboats are docked at the J & J wharf. On the left is the *William Numsen*; on the right is the *Robert W. Johnson*, built in Connecticut in 1905. Today, the headquarters is still along the Delaware and Raritan Canal in New Brunswick. (Courtesy of Johnson & Johnson.)

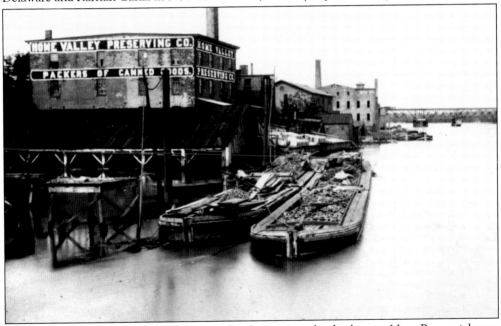

Throughout the canal's active life as a freight carrier, the harbor in New Brunswick was much wider than it is today. Home Valley Preserving Company, on Water Street, was one of many businesses there. The company received food from farmers in the region and packed it in cans for shipment via canal and railroad. In this September 1882 photograph, loaded hinged canalboats sit low in the water. The towpath is underwater due to recent rains that caused the Raritan to overflow its banks. (Courtesy of the Canal Society of New Jersey, Cawley Collection.)

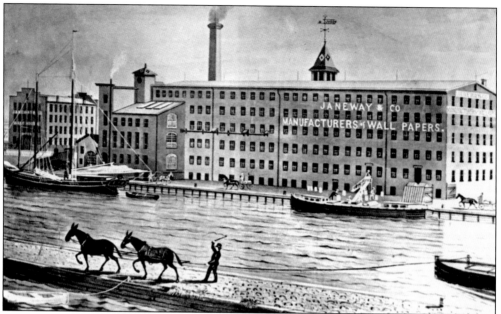

One of the first wallpaper manufacturers in the United States, Janeway & Company had three branches: Chicago, Philadelphia, and New Brunswick. The many boats tied up at the wharf indicate that Janeway used the canal to bring in paper and to ship out finished wallpaper products. Boats would be poled back and forth across the canal between the factory and the towpath. (Courtesy of Freese Camera Shop.)

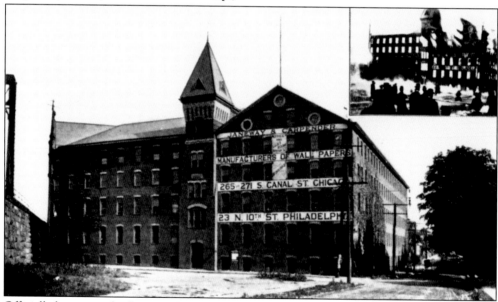

Officially known as the Janeway & Carpender Company, the business suffered a disastrous fire on March 13, 1907. As is evident from the inset, the building, at the corner of Schuyler and Paterson Streets, was gutted. Since the other branches of the company were still in business, the owners decided not to rebuild in New Brunswick. The owners must have appreciated the convenience of shipping by water, as the Chicago factory is on Canal Street. (Courtesy of Warner Studios.)

# Four

# THE VESSELS

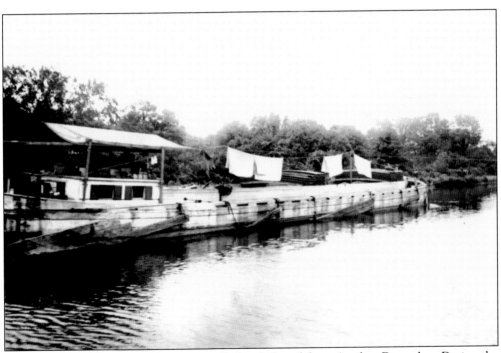

Families who operated canalboats generally lived aboard from April to December. During the winter, many returned to their permanent homes on shore, but some stayed on the boats year-round. Like many others, this family hangs the laundry while the vessel continues on its way. Such a sight was both common and necessary, as the canallers did not stay in one place long enough for the clothes to dry. (Courtesy of the Historical Society of Princeton.)

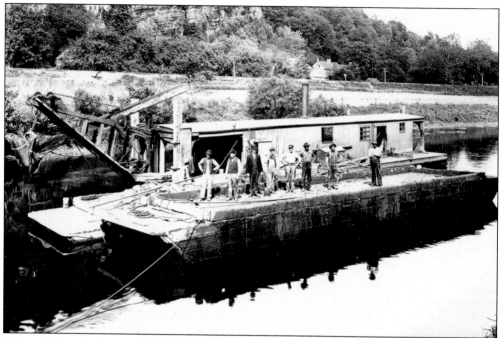

When bridges, locks, or other structures needed repairs, the canal company sent a work scow, or shanty, to the site. If the work was not urgent, it would often be completed in winter, when the canal was closed. Here, Shanty Boat No. 1 is moored downstream from the East Millstone bridge. In winter, the canal was partially drained, as seen here. (Courtesy of the Franklin Township Public Library.)

In this view, looking west toward the borough of Millstone, Capt. John Brittan's carpenter boat is tied up in the turning basin off Market Street in East Millstone. The canal company dispatched this vessel whenever repairs were needed anywhere on the waterway. These work boats contained living quarters, as well as tools and supplies. (Courtesy of the Franklin Township Public Library.)

Looking south from the East Millstone bridge, this view shows another work scow tied up along the bank. The wooden structure at the lower right is the cribbing that guided vessels into the bridge opening. This lessened the possibility of striking the bridge abutments.

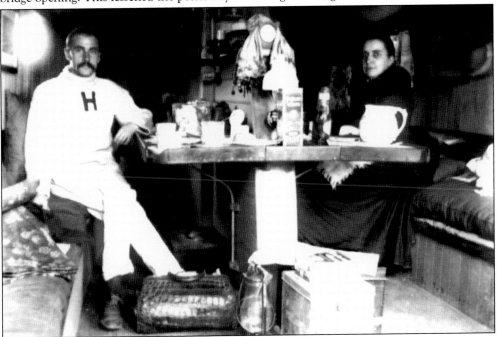

In 1892, noted American photographer Alice Austen (1866–1952) began a journey through the Delaware and Raritan and the Chesapeake and Delaware Canals. With her pilot, Ralph, and a friend nicknamed "Butterball," she sailed on the two-masted *Wabun*. This photograph of the interior shows the coziness of the cabin. According to canal historian Bill McKelvey, "The center partition housed the center board which had to be raised while navigating the canal." At her death, Austen left behind more than 7,000 negatives, now in the collection of the Staten Island Historical Society. Her home, in Alice Austen Park, is open Thursday through Sunday, from noon to 5:00 p.m. (Courtesy of the Canal Society of New Jersey.)

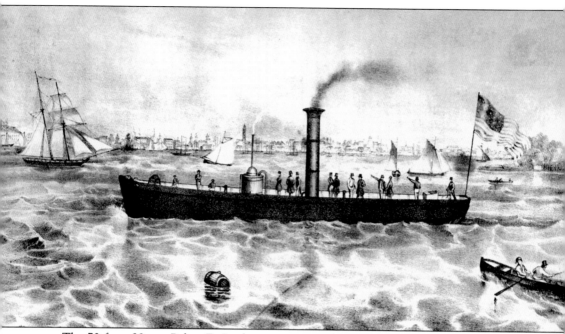

The 70-foot, 32-ton *Robert F. Stockton*, a steam tugboat, was built in Birkenhead, England, in 1839. In spite of early experiments by inventors such as Fitch, Fulton, and Stevens, Swedish-born John Ericsson is the man most closely connected with the introduction of the screw propeller, first successfully used on the *Robert F. Stockton*. Built of iron by order of the American naval officer whose name it bore, this tiny vessel made a hazardous Atlantic crossing under sail in April and May 1839. Admitted to U.S. documentation on May 8, 1840, by act of Congress (required because of its foreign construction), the boat was renamed the *New Jersey*. For 30 years, it was a towboat on the Delaware and Raritan Canal, becoming the world's first commercially successful screw-propelled steamer. Ericsson followed it to the United States, where he later designed the USS *Monitor*. (Courtesy of the Canal Society of New Jersey.)

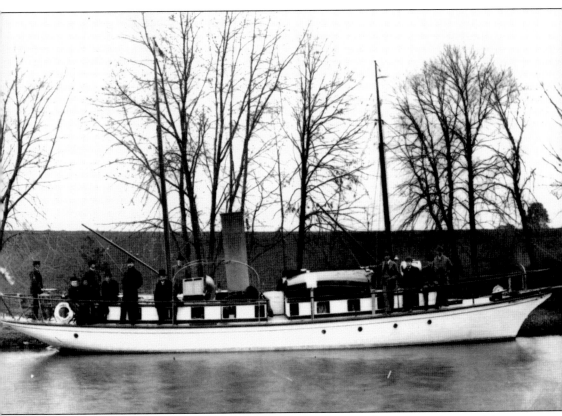

The *Alma*, a private, steam-powered yacht from Pittsburgh, is tied up along the canal in Princeton. The boat may have reached New Jersey by way of the Ohio and Mississippi Rivers to the Illinois and Michigan Canal, to Lake Michigan, through the Great Lakes to the Erie Canal, and south on the Hudson River. Another possible route may have been from the Ohio River north on the Ohio and Erie Canal to Lake Erie, and thence to the Erie Canal and the Hudson River. It would be great if we could follow those routes today. (Courtesy of the Canal Society of New Jersey.)

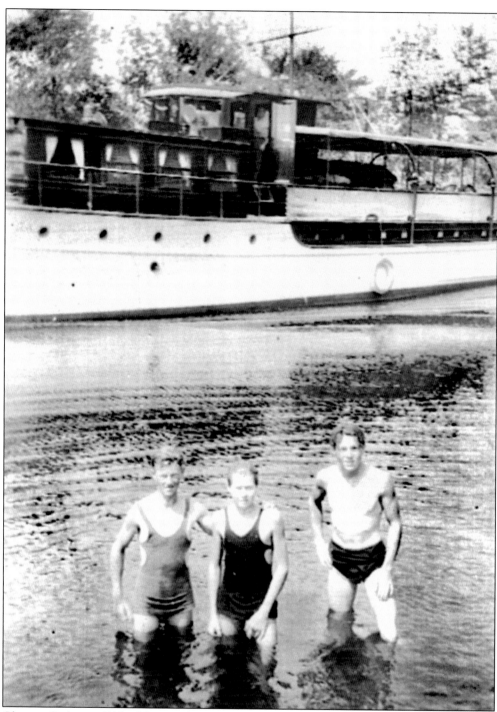

Clarence Pedersen, Eddie Olsen, and Arne "Mick" Arnesen cool off with a swim in the Delaware and Raritan Canal, as a yacht passes through the Norseville section of Griggstown. This area was informally referred to as Norseville after the arrival of many Norwegian-Americans, who established a summer bungalow colony. Eventually, many of these small houses became year-round homes. (Courtesy of the Franklin Township Public Library.)

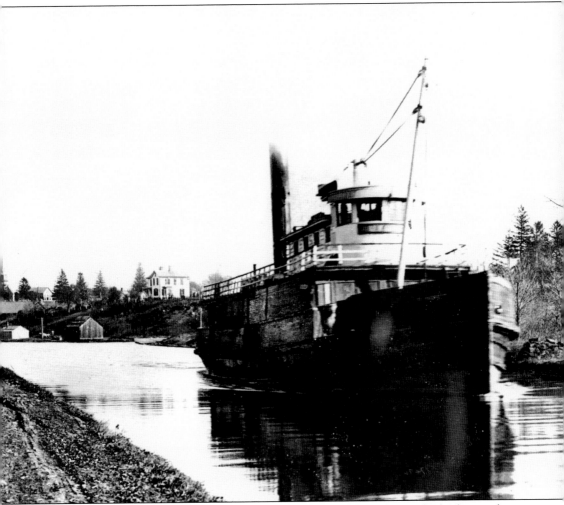

The steam canalboat *John W. Garrett* leaves the village of Kingston, visible in the background. Owned by the New York and Baltimore Transportation Line, this and other vessels of the line gave the Baltimore & Ohio Railroad a connection to New York City before it had trackage rights to enter directly by rail. (Courtesy of the Franklin Township Public Library.)

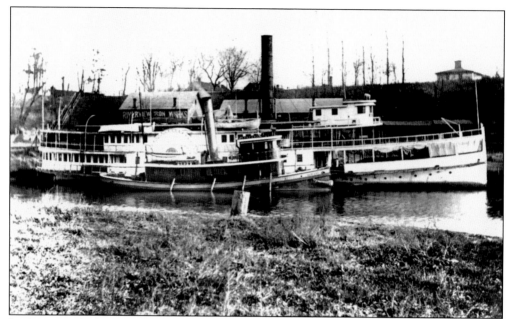

In this view, looking south from the entrance to Lock No. 1, an amazing variety of vessels is tied up in Crosswicks Creek below the bluff in Bordentown. Passenger steamboats leave daily for Philadelphia, and canalboats await a tow south to the Chesapeake and Delaware Canal. Freighters deliver their goods to local businesses, including the Riverview Iron Works, located on the south side of the creek.

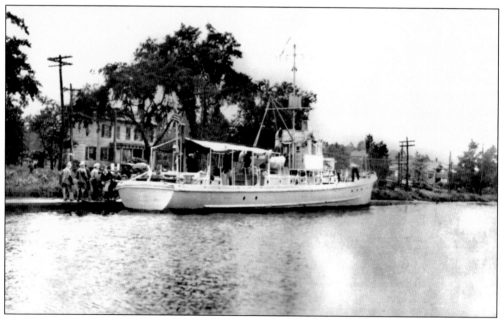

In 1861, at the onset of the Civil War, 14 Delaware and Raritan steam canalboats carried 3,000 troops and equipment to the defense of Washington, D.C. During World War I, the government used the canal for the safe transport of boilers and other naval supplies between the navy yards at Brooklyn and Philadelphia, and to Washington. Here, U.S. Navy Subchaser No. 252 is tied up, likely waiting to enter the lock.

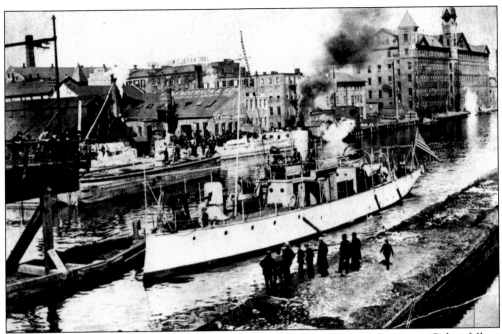

On July 17, 1898, during the Spanish-American War, the city of Santiago, Cuba, fell to American forces. The gunboat *Alvarado* was captured. The vessel came through the Delaware and Raritan Canal en route to Portsmouth, New Hampshire. Near the end of the canal in New Brunswick, the ship approaches the Albany Street swing bridge. (Courtesy of the Canal Society of New Jersey.)

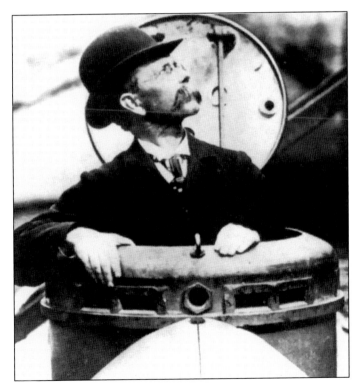

On May 22, 1878, Prof. John Holland launched his first submarine in the Passaic River, upstream of Great Falls. It initially sank but successfully submerged 14 days later. Holland then scuttled it to keep it a secret from his rivals. When he produced the more sophisticated *Holland VI* 22 years later, it was accepted by the navy. To reach the capital for the vessel's naval trials, Holland used the Delaware and Raritan. Due to the canal's eight-foot depth, the submarine was supported on pontoons. Here, Holland surveys the scene. (Courtesy of the Paterson Museum.)

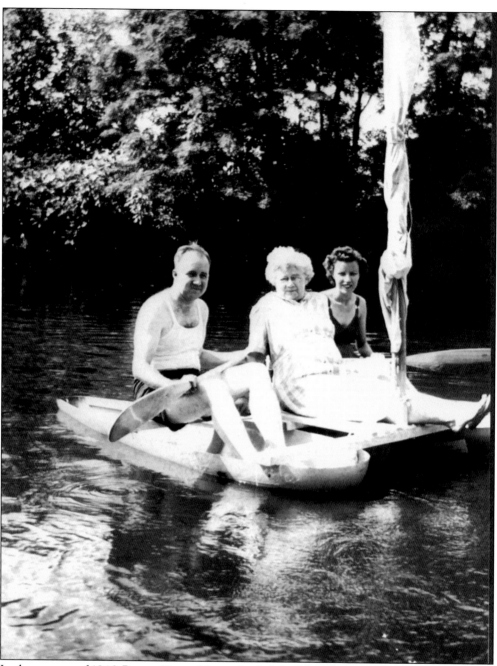

In the summer of 1946, Berton House (the author's father) bought a P-38 wing fuel tank from a war surplus store. Splitting the tank in half, he made two floats for a catamaran. Planks bolted to the flange of the tanks formed the deck. After adding a mast and sail, he and his family cruised along the Delaware and Raritan Canal in South Bound Brook. Some years later, Halloween pranksters punched holes in the floats, and the boat sank just south of the railroad trestle. Aboard on this trip are House's mother, Clara Riggs House, and his wife, Louise. Since this trip occurred a mere five months before the author's birth, she must have been along for the ride.

# *Five*

# THEN AND NOW

Taken from the bluff in Bordentown today, this northward view shows mainly the overgrowth that covers the site of Lock No. 1. The Bordentown Yacht Club appears in the foreground. The entrance to the lock can be seen as a small indentation among the trees. An on-the-ground exploration reveals only the wooden crib lock and the foundations of the canal buildings. The highway bridge on the left carries Interstate 295. This long-neglected section of the state park is scheduled for improvement in the future.

The large white building on the left is the office of the Delaware and Raritan Canal Company. To the right of that building stands the home of the locktender and harbormaster. In the background are the canal stables and a dormitory for mule drivers. The Camden & Amboy Railroad, now New Jersey Transit's River Line, appears in the foreground. (Courtesy of the Burlington County Historical Society.)

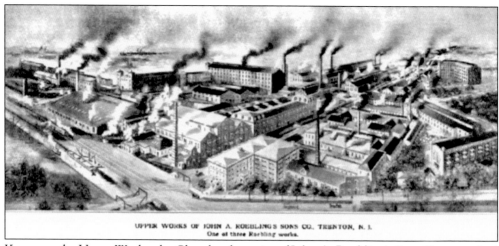

UPPER WORKS OF JOHN A. ROEBLING'S SONS CO., TRENTON, N. J.
One of three Roebling works.

Known as the Upper Works, the Chambersburg site of John A. Roebling's Sons Company had grown tremendously by 1908. The Roeblings had acquired the Buckthorn Fence Company factory six years earlier, a half-mile south along the canal. Relocated there, the Insulated Wire Division became known as the Lower Works, or the Buckthorn plant. (Courtesy of Clifford Zink.)

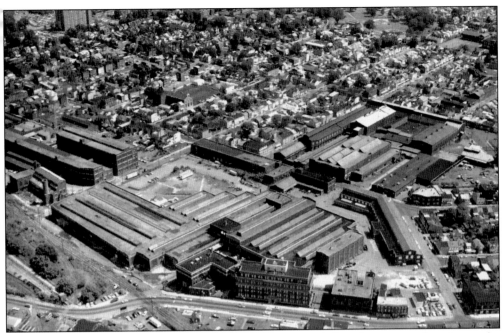

The residential section of modern-day Trenton has expanded and seems to close in on the Roebling complex. South Broad Street, running from lower left to right, more or less follows the route of the Delaware and Raritan Canal. Dye Street is the thoroughfare to the right of the complex; turning left, it becomes South Clinton. (Courtesy of Clifford Zink.)

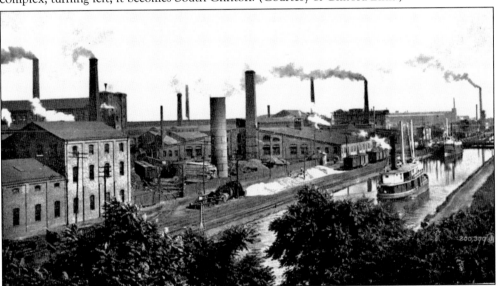

When John A. Roebling opened his wire rope-manufacturing business in Trenton in 1849, he chose an advantageous site along both the Delaware and Raritan Canal and the Camden & Amboy Railroad. Both transportation corridors proved excellent shipping facilities for his products. Roebling made wire rope for the aqueducts of the Delaware and Hudson Canal, for many of our country's suspension bridges, and for the inclined planes of New Jersey's Morris Canal. This 45-acre area was the city's flagship industrial complex through the middle of the 20th century.

Once Trenton's largest, most prominent industrial giant, the John A. Roebling Works site today is home to a much-needed full-service supermarket, a restaurant, retail stores, parking space, the New Jersey Home Mortgage Finance Agency, and a residential complex for senior citizens. Additional uses planned for the complex include office space, more restaurants, retail stores, housing, a YMCA, and a new school. Saved within the complex is the Roebling 80-ton wire rope machine, declared a National Mechanical Engineering Landmark in 1989. This view is looking east from the intersection of Hamilton Avenue and Route 129, just west of the Sovereign Bank Arena (left).

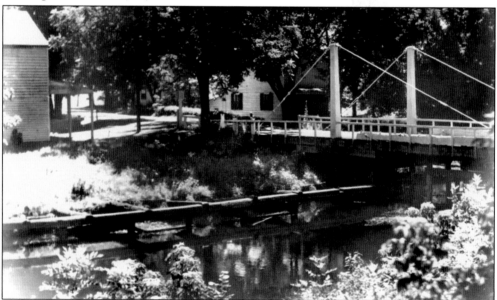

Here, at the tiny crossroads of Port Mercer, the bridgetender's house can be seen across the canal and under the trees to the right of the bridge. The building on the left is a private home. In the canal's early days, A-frame swing bridges were used for all crossings. This photograph was taken in the early 1900s, when the kingpost bridge had replaced the A-frame; these stronger spans were necessary to carry the heavier vehicles of the early 20th century. Note the wood cribbing that guides the boats into the bridge opening. (Courtesy of the Historical Society of Princeton.)

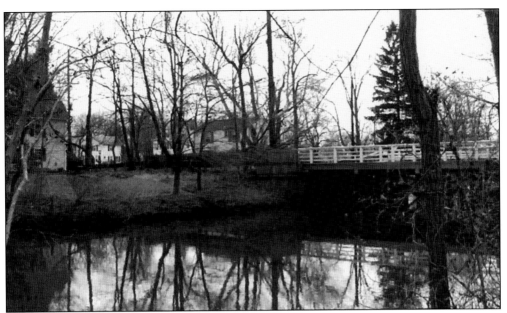

The original bridgetender's house still stands and is owned by the Delaware and Raritan Canal State Park. It is currently leased by the Lawrence Historical Society. As with all of the road bridges over the canal, the New Jersey Department of Transportation has replaced the kingpost bridge with a fixed bridge. The building at the far left remains a private home.

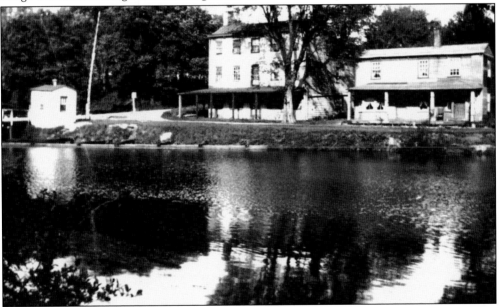

This view, looking east across the basin at Princeton, gives a broad view of this busy stop. On the far left is the swing bridge at Alexander Road (formerly Canal Road), with the small tender's hut. The vertical pole to the right of the hut was a gate that stopped vehicular traffic when the bridge was open for vessels. On the right are two important businesses. The taller one is the Steamboat Hotel, known as the Railroad Hotel until 1864, when the tracks were relocated to Princeton Junction. The smaller structure housed a general store. (Courtesy of the Historical Society of Princeton.)

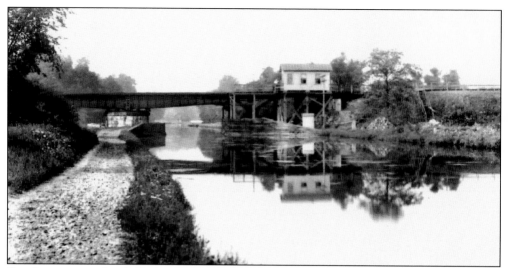

Standing just north of Alexander Road, the photographer has captured this striking scene. The towpath, bare of trees on the water side, is dotted with the hoofprints of mules. Ahead is the bridge of the Dinky Railroad, the nearly three-mile branch line of the Pennsylvania Railroad, built to connect the borough to the main line station at Princeton Junction. The curved extension of the towpath, on the left, allowed the mules to walk around the bridge support without unhitching the towlines. On the right side of the bridge is the shed from which the tender controlled the signals to stop the Dinky before he opened the bridge. (Courtesy of the Historical Society of Princeton.)

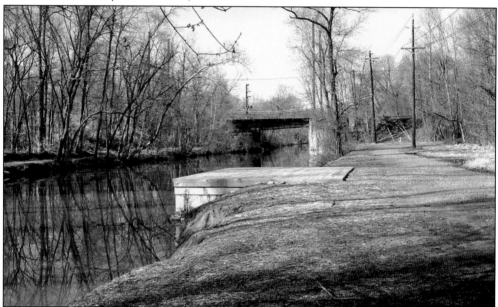

The Princeton branch railroad, referred to as the PJ & B (Princeton Junction & Back), continues to operate every day, carrying commuters and college students to the main line, as it has for almost 140 years. It is the shortest rail route in the New Jersey Transit system. From Princeton Junction, passengers can take a Northeast Corridor train to New York, Philadelphia, and points beyond. This bridge spans one of the most popular sections of the Delaware and Raritan Canal State Park.

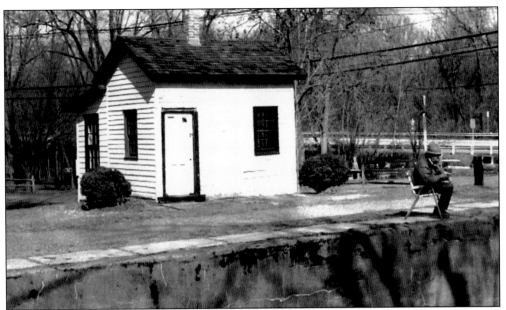

Today, the parking lot at Lock No. 8 in Kingston is usually full. Bikers, walkers, and joggers frequent the towpath south to Princeton and north to Rocky Hill, and fishermen angle for catfish and trout. Interpretive signs explain the workings of the lock and the construction of the canal. The telegraph office, which also served as the locktender's hut, is now used only for storage. Next-door, the tender's home contains exhibits.

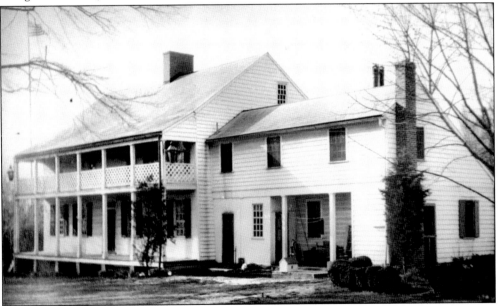

Rockingham, built in the early 1700s, was once the home of Judge John Berrien. It served as Washington's headquarters while the Congress met in Nassau Hall in nearby Princeton in 1783. Congress rented the home for use by the general from August 23 to November 10, 1783. Here, Washington wrote his Farewell Orders to the Armies of the United States, in which he recognized the service of his countrymen and announced his own retirement from public life. (Courtesy of the Franklin Township Public Library.)

Today, neither the railroad station nor the bridgetender's house remains in Rocky Hill. Modern Route 518 has replaced the old road crossing the canal. Trap Rock Industries has constructed an interpretive site at the approximate location of the bridgetender's house, which burned in 1964. Visitors can read about the Atlantic Terra Cotta Company, the quarry, Rocky Hill, and the canal. A stylized version of the house foundation gives the visitor an idea of its location.

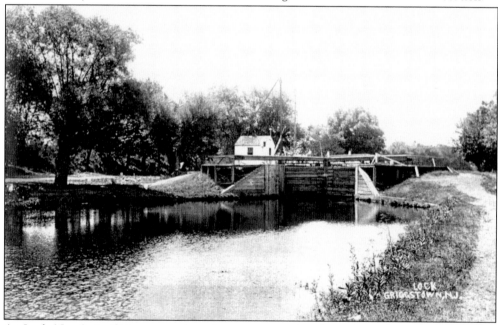

At Lock No. 9, in Griggstown, the miter gates are closed, awaiting the next vessel. The locktender's home is just out of sight beyond the little white shanty, where the tender waits for approaching boats. Note the lack of trees between the water and the towpath; the bank was kept clear to accommodate the towline. (Courtesy of the Franklin Township Public Library.)

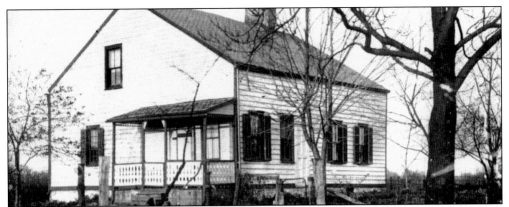

When the Colonies declared their independence, John Honeyman convinced Washington that he could act as a spy for the British but actually spy for Washington. In the role of a cattle dealer and butcher, he procured provisions for the British, going in and out of British camps without arousing suspicion. He moved to Griggstown, where he angered his neighbors with talk of loyalty to the crown. On December 23, 1776, Honeyman allowed himself to be captured by two American soldiers. Meeting alone with the general, he presented a detailed layout of the Hessian encampment in Trenton. The "spy" was placed in the guardhouse, but during a mysterious fire, he used a concealed key (provided by Washington), unlocked the guardhouse door, and escaped. (Courtesy of the Franklin Township Public Library.)

Returning to Trenton, Honeyman convinced Col. Johann Rall that the Continental army was on the verge of mutiny. As Rall planned for a Christmas celebration, Washington crossed the Delaware on Christmas Night. In Griggstown, the news of Honeyman's treachery incited an angry mob that threatened to burn the Honeyman house if he did not come out. Honeyman, however, was not in Griggstown, and his wife demanded to know who was in charge. When a neighbor stepped forward, she handed him a letter to be read aloud to the mob: "To the good people of New Jersey, and all others whom it may concern. It is hereby ordered that the wife of John Honeyman, of Griggstown, the notorious spy, now within the British lines, and probably acting the part of a spy, shall be and are hereby protected from all harm and annoyance from every quarter until further orders. But this furnishes no protection to Honeyman himself. George Washington. Commander-in-Chief." This historic home, at the corner of Canal and Bunker Hill Roads, is still privately owned. A small plaque on the front recalls its moment in history.

This photograph was taken from a spot between the canal (left) and Canal Road (right). Sandor Fekete, the last bridgetender, lived here long after the canal closed. The small building in the foreground was actually a former railroad structure. The original tender's hut has now been moved to the back of the home and attached as an addition. (Courtesy of the Franklin Township Public Library.)

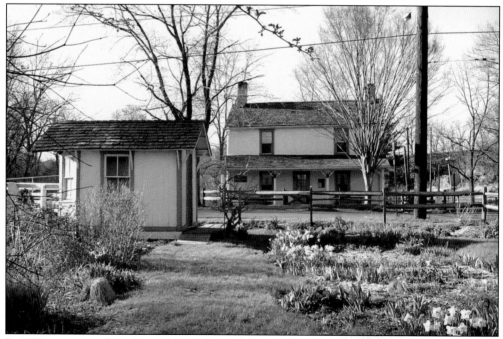

In 1971, a group of local canal buffs formed the Blackwells Mills Canal House Association. They leased the house from the state and lovingly restored it as it may have looked when it housed the bridgetender. The Canal House is now open to the public monthly for craft and antique shows, art exhibits, children's events, market days, plant sales, and much more.

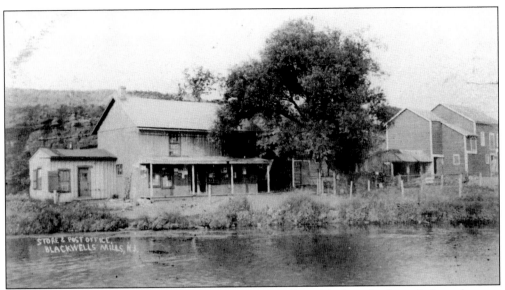

Built in 1898, the structure on the left was originally a blacksmith shop. It later became Nordenbrook's General Store and the Blackwells Mills Post Office. Nordenbrook moved to this building, on the Franklin Township side of the Millstone River, when his store in Hillsborough burned. (Courtesy of the Franklin Township Public Library.)

The building (now bright red and without the porch) still stands today, on Canal Road just north of the intersection at Blackwells Mills. The store is gone, leaving only a lovely green space in its place.

Built for East Millstone merchant Nathaniel Wilson c. 1888, the Wilson House was later the residence of Dr. Cooper, who maintained an office there. Overlooking the Delaware and Raritan Canal, the house occupies the corner of Market Street (formerly Basin Street) and Bradley Avenue. Its original cupola is now gone, but the house remains an excellent example of High Victorian eclectic architecture, with its Eastlake porch and entrance and large brackets along the cornice.

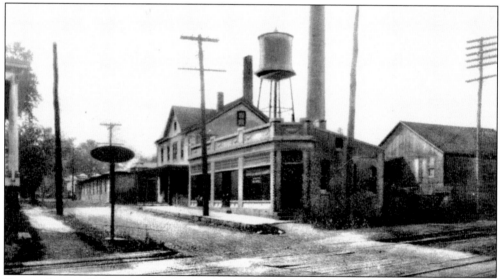

During the canal's busiest years, East Millstone (formerly Johnsville) was a bustling town. This view, looking south on Market Street c. 1910, was taken from a point next to the railroad tracks. Market Street was known as Basin Street then, because it ran along the canal's turning basin. Many buildings backed onto the canal, providing easy access for loading and unloading merchandise. The water tower shows the location of the Fleischmann Distillery. (Courtesy of the Franklin Township Public Library.)

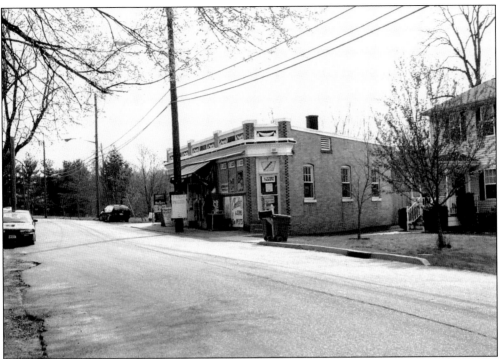

Few of the buildings along the west side of Market Street remain. The corner building now houses Chester's Market. The distillery and rubber-reclaiming factory complex, marked by the water tower in the previous photograph, was demolished; the water tower and two smokestacks remained until 1990.

Many stores and other businesses surrounded the basin in East Millstone. Some are out of the photographer's view to the south (right) of the image. The three-story brick building (left) has had many occupants over the years. In its early years, it housed Thatcher's Drugstore and Gannon's Bakery. In 1898, it became the Odd Fellows Hall. In the center, the Nathaniel Wilson house retains its cupola. (Courtesy of the Franklin Township Public Library.)

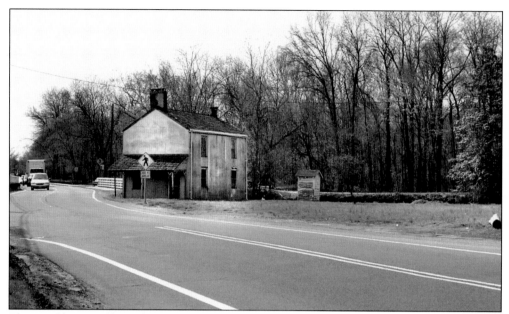

The canal house still stands in East Millstone but is no longer occupied. For a time, the Delaware and Raritan Canal State Park leased the canal buildings, including this one. The last tenant left many years ago, and the house is no longer habitable. A privy, or necessary, stands to the side. The A-frame swing bridge has been replaced by a fixed span.

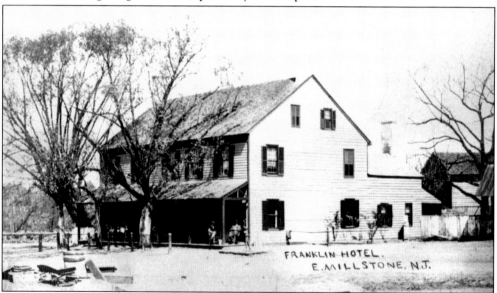

Believed to be the oldest structure in East Millstone, the Franklin Inn was originally a farmhouse, built by Cornelius Van Liew in 1752. During the Revolution, it served as the headquarters for British general Charles Cornwallis. John Wyckoff, a later owner, converted the building to an inn in 1829. As Bill Brahms, in *Franklin Township, Somerset County, NJ: A History*, notes, "Speculation about the impending canal may have been the reason a brick addition was put on the building, to be used as a kitchen." The inn was closed in 1916, and the building was passed down through the Mettlar family until it was sold to the Onka family in 1953 and used for storage. (Courtesy of the Franklin Township Public Library.)

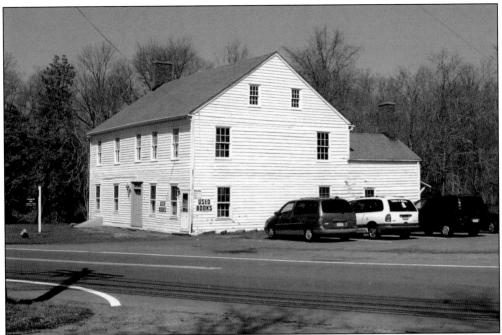

Now managed by the Meadows Foundation, the Franklin Inn is being restored by the Blackwells Mills Canal House Association. The association leases the inn from the Onka family, owners since 1953. Opening as a used book store in November 1992, the building now houses 20,000 books. The store is open on Saturday, Sunday, and Wednesday afternoons.

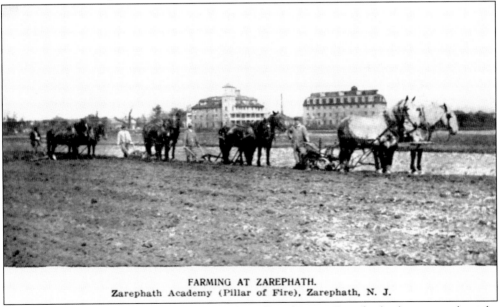

FARMING AT ZAREPHATH.
Zarephath Academy (Pillar of Fire), Zarephath, N. J.

The structure on the left is the main hall of the Pillar of Fire at Zarephath; the one on the right is Liberty Hall. The smokestack of the powerhouse is visible in the background. Just to the right of the farmer in the white shirt is the old Garretson black walnut tree, under which, tradition says, Continental army soldiers camped. These Pillar of Fire members were photographed from across the canal along Weston Canal Road, not much more than a dirt trail at that time.

Over the years, the Pillar of Fire established a radio station (WAWZ), seven schools (including Alma White College), and a large religious publishing program. By 1936, the church owned property worth an estimated $4 million and had more than 4,000 members in 46 congregations. The community now operates the Somerset Christian College, as well as elementary and high schools. The chapel on the far left was built c. 1925 on the site of the Garretson farmhouse. The deteriorated house was not saved, but care was taken to preserve the walnut tree. Sadly, a few years ago, the tree was removed due to its unhealthy condition.

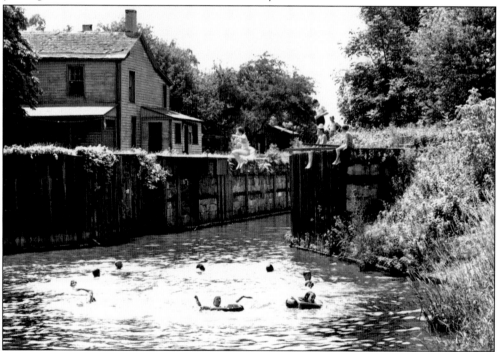

These youngsters have found a delightful way to cool off on a summer day. The miter gates are missing here, at the downstream end of Lock No. 11, marking the end of the canal's life as a freight carrier. This is a rare view of the locktender's house in South Bound Brook.

The locktender's home no longer looms over the wall at Lock No. 11. This and other canal buildings are gone, making room for the green space of the park and its picnic tables. Often the employees of local businesses enjoy a peaceful lunch in this scenic setting. Note, too, that trees now grow along the towpath, a sure sign that mules are no longer pulling along canalboats.

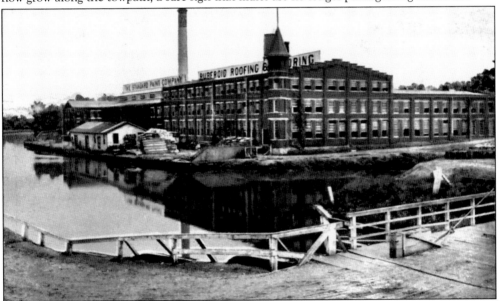

In this turn-of-the-century view, the Standard Paint Company has changed its name to include Ruberoid Roofing and Flooring. The slip between the bridge and the factory is very clearly shown. Some details of the swing bridge are seen at the lower right. (Courtesy of the Franklin Township Public Library.)

The borough of South Bound Brook has plans to convert this abandoned manufacturing site into a multiuse development, with a waterside promenade, shops, and housing. The town has already created a municipal logo of a mule-drawn canalboat to welcome visitors.

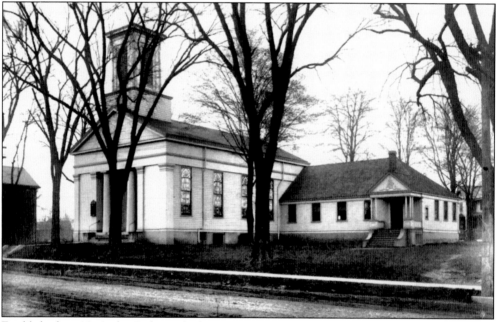

Established in 1846, the Reformed Church of Bound Brook actually stands in South Bound Brook, just across Main Street from the canal. According to Elder Frank Burd, "Tradition says that the question of whether to build the new church on the north or south side of the river was decided by granting first to the north side the privilege of endeavoring to raise two thousand dollars necessary for building the church. Their attempt was unsuccessful so the south side was given the same opportunity and the required sum was soon raised. Early in 1847 a plot of ground fronting on the Easton Turnpike was bought from Jacob Shurts, and on August 23, 1847, the cornerstone was laid with appropriate ceremonies."

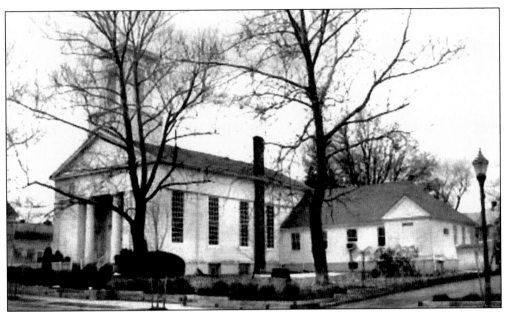

Over the years, the Reformed congregation has closed the entry at the right (seen in the previous photograph) and built Fellowship Hall, across Clinton Street and behind the sanctuary. In the hall, the author remembers setting up pins by hand in a bowling alley. The pinsetter stepped on a pedal to raise metal points in the floor, set the wooden pins upon these points, and released the pedal. The street lamp on the far right is part of the borough's new streetscape.

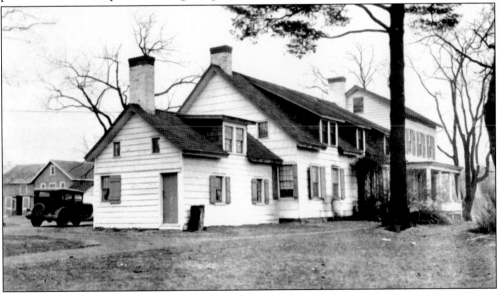

In 1738, Peter Staats purchased a 305-acre plantation extending south from the Raritan River. A two-room Dutch cottage was expanded in the 1770s and again in the 1820s. Abraham Staats lived here from 1769 or 1770 until his death in 1821. During the Revolution, when the British occupied New Brunswick, Staats was one of three patriots who were specifically excluded from the British pardons. Later, during Washington's Middlebrook Encampment of 1778–1779, Baron Von Steuben was quartered here. In May 1779, Von Steuben presented the troops to Washington and the French minister M. Girard.

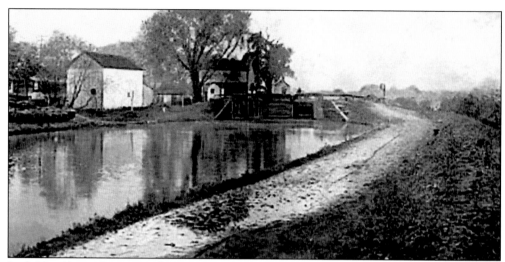

Lock No. 12 was known to the canallers as Five-Mile Lock, due to its distance from the end of the canal in New Brunswick. In fact, it is 5.88 miles from the terminus. It was here that the Fieldville Dam backed up the water of the Raritan River so it could be diverted into a culvert. The water entered the canal just downstream of the lock. The culvert is no longer used. Recently it was sealed, and the historic gate was removed.

This scene is difficult to see today, for several reasons. Trees have grown along the towpath and the state park access bridge crosses over the lock and blocks the view of the chamber. In addition, the abutment supporting the Interstate 287 bridge rests in the canal at the water's edge. Water running down from the roadway continually erodes the towpath at this point. To solve the problem, the New Jersey Water Supply Authority has reinforced the towpath with concrete and covered it with stone.

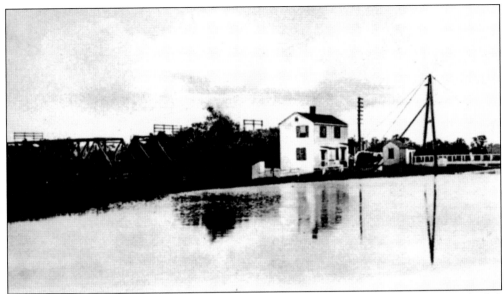

Looking downstream, this view shows the Landing Lane bridge. The iron bridge on the left carries Landing Lane over the Raritan River, connecting New Brunswick with Piscataway. The bridgetender's home, next to the towpath, is typical of the houses built by the canal company for its employees. As usual, the bridgetender's hut sits next to the A-frame swing bridge. (Courtesy of the Franklin Township Public Library.)

The old iron bridge over the Raritan River was replaced in the 1990s by this modern, prestressed concrete span. The New Jersey Department of Transportation has made all of the canal's swing bridges fixed structures, as exemplified by the Landing Lane bridge. No longer needed, the historic bridgetender's home was razed long ago.

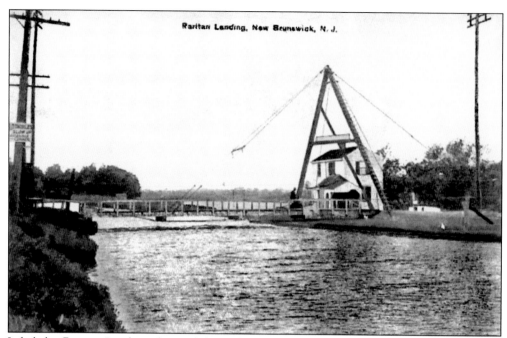

Labeled as Raritan Landing, this card shows the upstream view, the opposite of the image on the previous page. It provides a much clearer view of the A-frame and the rigging that connected it to the swing bridge. In addition, one can see the telegraph poles that provided a vital communication link among the canal employees. The sign on the pole states, "Automobiles Slow Up—Dangerous Corner," and so it remains today. (Courtesy of the New Brunswick Public Library.)

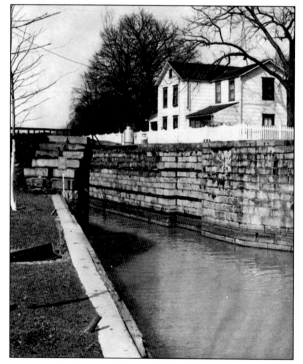

In this Jack Boucher photograph of Deep Lock for the Historic American Buildings Survey, taken in March 1960, the miter gates have been removed to allow water to flow downstream. This image is one of the few showing the historic locktender's house. In the 1970s, when plans were made to fill in the lock, the city agreed to move the house to the outlet lock (Lock No. 14) to serve as a museum. Unfortunately, the house was destroyed under mysterious circumstances. (Courtesy of the Library of Congress.)

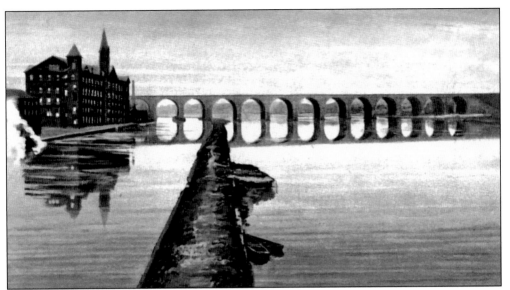

Throughout most of its life, the Delaware and Raritan Canal was open to vessels of any height, because all its bridges swung. In 1903, however, the Pennsylvania Railroad built a new stone-arched bridge (in the distance), limiting overhead clearance to 50 feet. The protrusions along the towpath, jutting into the Raritan River, may be extensions placed at the waste weir to prevent erosion of the canal bank when the excess water flowed into the river. (Courtesy of the New Brunswick Public Library.)

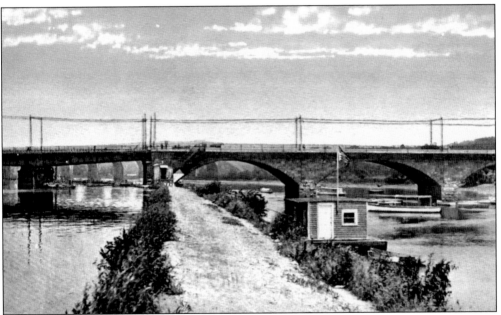

Across the canal harbor, to the left, was a busy manufacturing area. Among the businesses was Star Linseed Oil. In the 1976 film *The Delaware and Raritan Canal*, producer and writer Cliff Crawford describes the history of the ill-fated plant. "The Star Linseed Oil, White Lead, and Color Works factory was built in 1866, burned in 1870, was rebuilt in 1871, re-burned in 1875. The 300 employees became rather discouraged by the fortunes of the paint business."

Today, the Delaware and Raritan Canal is the centerpiece of the redeveloped Boyd Park, in New Brunswick. The canal harbor, much narrowed, appears on the left. In 1998, as mitigation for destroying Lock No. 13 and burying the canal upstream, the New Jersey Department of Transportation, in partnership with the city of New Brunswick, restored this area.

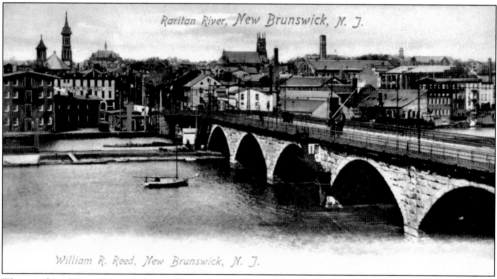

This early-1900s view of the Albany Street bridge looks toward New Brunswick from the Highland Park side of the Raritan River. The canal harbor is clearly visible, as are many of the factories lining its banks. The towpath runs under the far arch and continues on the other side of the span. The building on the far left is the New Jersey Rubber Company. To the right is the Raritan House Hotel. Under the "B" in New Brunswick is the steeple of St. Peter's Roman Catholic Church, still located on Somerset Street. (Courtesy of the New Brunswick Public Library.)

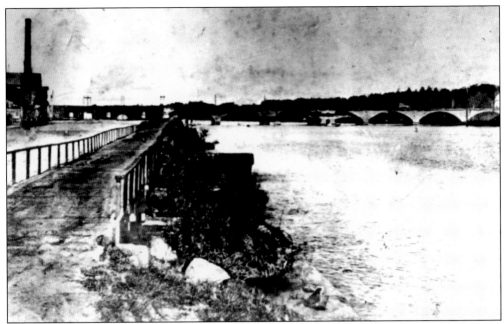

This wooden bridge permitted mules to cross the waste weir in New Brunswick. The weir is a controlled opening in the towpath through which excess water is allowed to flow into the Raritan River. In this upstream view, the Albany Street bridge appears in the distance. (Courtesy of the Franklin Township Public Library.)

Made of heavy timber cribbing filled with rubble stone, the waste weir remains, just downstream of the Albany Street bridge. Today, water still flows over the weir into the canal at high tide. The weir's elevation was lowered during the towpath renovations of 1998. When the outlet locks were restored, this bridge was not re-created. As one walks upstream from the locks today, the towpath ends at the weir; a pedestrian bridge carries strollers back to the mainland. Another bridge, visible in the distance, returns the visitor to the towpath beyond the weir.

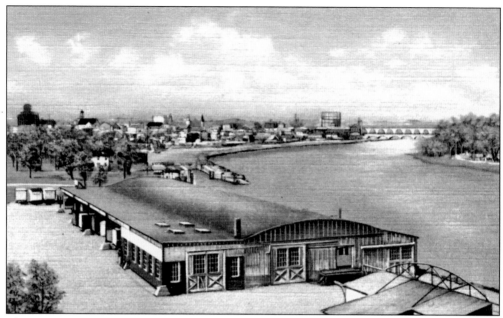

The Municipal Dock, built after the canal closed, dominated the riverside just beyond the double outlet locks (Lock No. 14) in New Brunswick. Steamboats from New York, Perth Amboy, and towns downstream stopped here to pick up and discharge freight.

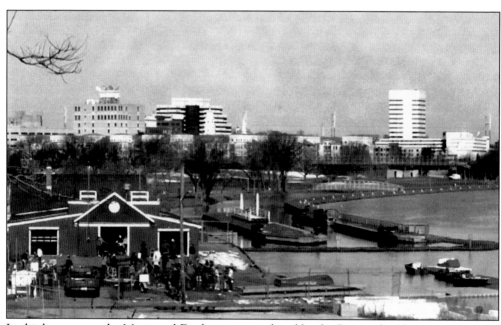

In this busy scene, the Municipal Dock is gone, replaced by the Rutgers boathouse, a gift of the Rutgers class of 1914. On a cool March day, members of the Rutgers University crew team carry their shells into the university boathouse after a brisk morning practice on the Raritan River.

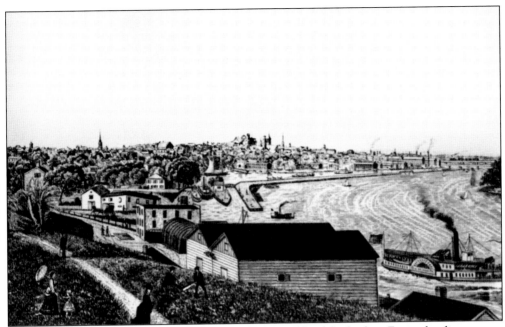

This postcard clearly shows the outlet locks and the width of the harbor. Far in the distance are the Albany Street bridge and the Pennsylvania Railroad's new stone span. A steamboat chugs downstream past the Municipal Dock, which dominates the shoreline.

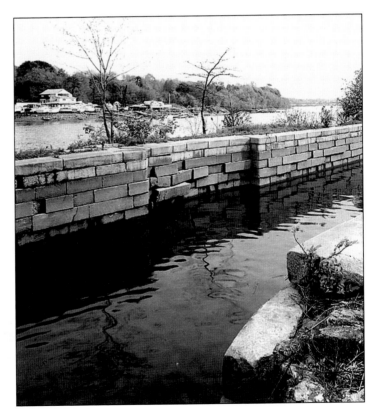

After the canal closed in 1932, the New Brunswick harbor continued to be used. In later years, trees grew along the towpath and on the lock stones; their roots forced the historic stones out of alignment. In this c. 1968 photograph, one can see the circular pocket (far wall) into which the miter gate fit when opened. A tree grows in the pocket on the opposite wall. As late as the mid-1990s, the author could not walk along the lock wall without clippers to clear the brambles out of the way. (Courtesy of the Library of Congress.)

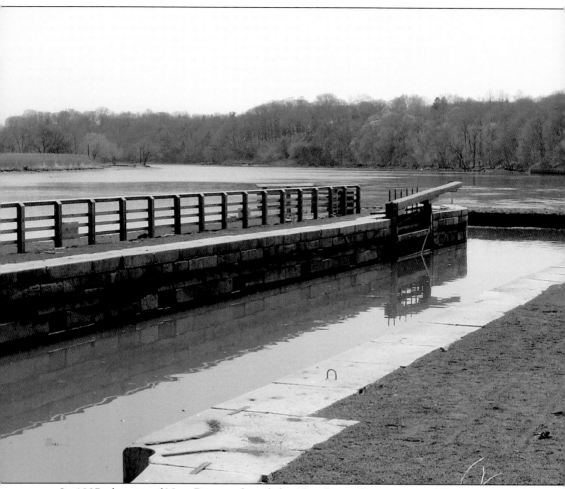

In 1997, the city of New Brunswick and the New Jersey Department of Transportation began a project to restore the double outlet locks and the towpath in Boyd Park in response to the destruction of the canal 20 years earlier. The towpath was cleared and resurfaced, and lighting was added. A new drop gate and miter gates were manufactured for both locks. Originally, the outboard lock (the one closest to the river) handled all of the locking. Later, when traffic increased, the inboard lock was constructed; it has a drop gate on the upstream end and miter gates on the downstream end. The restored area, opened in 1998, has many signs detailing the history and workings of the Delaware and Raritan Canal. A replica swing bridge was created, but 13 months after the grand opening, Hurricane Floyd washed it several miles downstream. To its credit, the city of New Brunswick then built a second bridge, which now swings in Boyd Park.